IMAGES
of America

PHILADELPHIA GRAVEYARDS
AND CEMETERIES

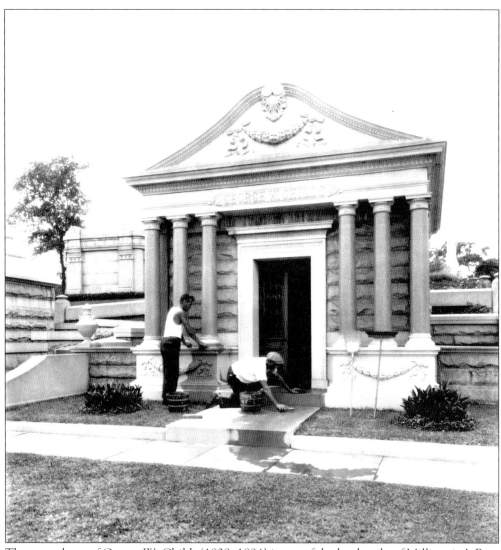

The mausoleum of George W. Childs (1829–1894) is one of the landmarks of Millionaire's Row at Laurel Hill Cemetery. The row is a string of elaborate memorials to the self-made magnates who dominated Philadelphia business and politics after the Civil War. Childs was a publisher of Victorian bestsellers including *Arctic Explorations* by Elisha Kent Kane, a fellow resident of Laurel Hill (see page 27). In 1864, Childs purchased the *Public Ledger* and built it into Philadelphia's leading newspaper. In the 1880s, he joined forces with financier Anthony J. Drexel to develop the Main Line town of Wayne. His tongue-in-cheek justification of his investment was that if people had to travel by train to Wayne, they'd have more time to read the *Public Ledger*. Childs delighted in the lavish entertainment of celebrities, either at his mansion at Walnut and Twenty-second Streets in Philadelphia or at his Bryn Mawr estate (today St. Aloysius Academy). This 1930 publicity shot, showing Laurel Hill workers scrubbing the Childs mausoleum, was designed to impress potential customers with the cemetery's careful maintenance of its monuments. (Laurel Hill Cemetery Company.)

IMAGES of America
PHILADELPHIA GRAVEYARDS AND CEMETERIES

Thomas H. Keels

Copyright © 2003 by Thomas H. Keels.
ISBN 0-7385-1229-X

First printed in 2003.

Published by Arcadia Publishing,
an imprint of Tempus Publishing Inc.
2A Cumberland Street
Charleston, SC 29401

Printed in Great Britain.

Library of Congress Catalog Card Number: 2003104866

For all general information, contact Arcadia Publishing:
Telephone 843-853-2070
Fax 843-853-0044
E-mail sales@arcadiapublishing.com

For customer service and orders:
Toll-free 1-888-313-2665

Visit us on the Internet at www.arcadiapublishing.com.

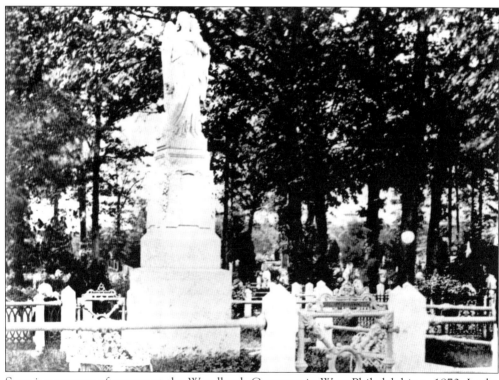

Seen is a summer afternoon at the Woodlands Cemetery in West Philadelphia c. 1870. In the heyday of rural cemeteries, every effort was made to create a serene and beautiful environment where visitors could sit on grave furniture like the bench above and meditate upon their departed ones. Much of the furniture and iron fencing common to such plots has since disappeared, the victim of wartime metal drives, decay, or thieves. (Library Company of Philadelphia.)

CONTENTS

Introduction		6
Acknowledgments		7
1.	Colonial and Federal Graveyards	9
2.	Laurel Hill Cemetery	21
3.	The Woodlands	35
4.	Other Victorian Cemeteries	49
5.	Neighborhood Graveyards	65
6.	African American Burial Sites	79
7.	Catholic and Jewish Cemeteries	91
8.	The Trappings of Death	105
9.	Vanished Cemeteries	115
Index		127

INTRODUCTION

Show me your cemeteries, and I will tell you what kind of people you have.
—Benjamin Franklin

In Philadelphia, it should be "Rest in Pieces," not "Rest in Peace."
—Anonymous Web site contributor

Philadelphia's cities of the dead have always been mirrors of the living city, reflecting its self image in the lustrous marble and polished granite of their monuments. The communal burial grounds of 17th-century Philadelphia befitted a newborn pioneer town whose citizens struggled to survive. Within a few decades, Philadelphia had grown into America's political and mercantile capital with a complex social hierarchy. Its 18th-century cemeteries denoted where each individual stood (or lay) within that pecking order, from the elegant obelisks and table tombs of Christ Church to the unmarked trenches of the Strangers' Burial Ground.

Cemeteries were a source of pride to 19th-century Philadelphia. They reflected its manufacturing muscle, technical innovation, physical expansiveness, and widespread prosperity (*a chicken in every pot, and a plot for every body*). The beauties of Laurel Hill, the Woodlands, and Mount Moriah were celebrated in woodcuts and stereo views circulated worldwide. Every self-respecting Philadelphia neighborhood boasted a miniature version of them, complete with a grandiose gateway, Civil War memorial, and a row of mausoleums for the local gentry.

In the 20th century, Philadelphia's attitude toward its cemeteries turned to either indifference or shame. This was due in part to Americans' emotional distancing from death during this time, but also to Philadelphia's changing status after World War II. As its industries, economy, and population declined, the city tried to reinvent itself as "Olde Philadelphia," a Colonial Revival Disneyland with Independence Hall as Cinderella's castle. Cemeteries that conformed to this revisionism—especially those that boasted Revolutionary War notables—survived. Other graveyards, mostly Victorian ones, suffered the same fate as trolley cars and Frank Furness buildings. They were obliterated in the name of urban renewal (and political cronyism), their tombs used as landfill and their bodies dumped in mass suburban graves.

Today, both Philadelphia and its cemeteries are in flux. Laurel Hill and the Woodlands are in stable condition, beneficiaries of loyal friends' groups and their status as National Historic Landmarks. A few lucky sites, including Christ Church, Fair Hill, and Hebrew Mutual Burial Grounds, have found new life after massive restoration efforts. Some cemeteries, such as Mount Moriah and Mount Peace, are active but bear little resemblance to their original state. Others—from Mount Vernon Cemetery, burial site of John Barrymore, to the tiny churchyards that dot the city—exist in a limbo of decay and neglect.

As with historic houses, Philadelphia is blessed and cursed with a surfeit of historic cemeteries, remnants of a day when its expansion seemed eternal. While this book offers a pictorial overview, various scholars are now compiling comprehensive surveys of past and present burial sites in Philadelphia. With luck, these inventories will serve as the basis for an organized and systematic campaign to rescue endangered burial sites from complete extinction.

Acknowledgments

Philadelphia Graveyards and Cemeteries is a testament to the generosity of individuals and institutions in the Philadelphia region who graciously shared their collections and expertise with me.

Special thanks must go to a group of individuals who, in addition to providing illustrations for the book, offered editorial and academic guidance, shared their own research, and guided me through cemeteries: Gloria Boyd; Lois and Michael Brooks; Eric J. Schmincke; Robert Morris Skaler; Barbara and Wilson Smith (the Burlington Smiths); Eugene Stackhouse; Andy Waskie, Ph.D.; H. Blair Anthony and William A. Sickel of R.R. Bringhurst and Company; Nevin W. Mann of the West Laurel Hill Cemetery Company; and Harvard C. Wood III of H.C. Wood Memorials.

My thanks also go to the following individuals for their valuable contributions and assistance: Harry Boonin; Carolyn Cades; Tom Crane; Dr. John Paul Decker; Hugh Gilmore; Jane Hamilton; James Hill Jr.; E.R. Hurvich; Elizabeth Farmer Jarvis; Harry Lamb; Emma Lapsansky, Ph.D.; Timothy Preston Long, Ph.D.; Lani L.P. MacAniff; Joseph J. Menkevich; Henry Nechemias; Roger T. Prichard; John Schimpf; Richard Snowden; Shirley Swaab; Vincent E. Summers; Ginny Warthen; William Wilson; and Len Williams.

I am indebted to the following institutions, and the individuals associated with them, for allowing me access to their collections and archives: 69th Pennsylvania "Irish Volunteers" (Don Ernsberger and Dr. Robert Levine); African Episcopal Church of St. Thomas (Mary Sewell-Smith); Association for the Preservation of Abandoned Jewish Cemeteries (Stanley N. Barer); Athenaeum of Philadelphia (Bruce Laverty, Jill LeMin Lee, Ellen Rose, and Michael Seneca); Bensalem Historical Society (Sally Sondesky); Blockson Afro-American Collection, Temple University Libraries (Charles L. Blockson); R.R. Bringhurst and Company (Chris Fario); Center for the Study of the History of Nursing, University of Pennsylvania School of Nursing (Karen Buhler-Wilkerson, Gail Farr, and Betsy Weiss); Chestnut Hill Historical Society (Peter Lapham and Audrey Simpson); *Chestnut Hill Local* (Katie Worrall); Chestnut Hill United Methodist Church (Rev. Hal Taussig); Christ Church Preservation Trust (Donald U. Smith); Church of St. James the Less (Rev. David Ousley); Congregation Mikveh Israel (Louise Cohen, Ruth Hoffman, Louis Kessler, and David Wundohl); Congregation Rodeph Shalom (Sue Popkin); Eden Cemetery Company (Junious Rhone); Fair Hill Burial Ground Corporation (Margaret Bacon and Mary Anne Hunter); Friends of Mount Moriah Cemetery (Chris and Dolly Beecher); Genealogical Society of Pennsylvania (Dottie Rogers); Germantown Historical Society (Mary K. Dabney, Marion Rosenbaum, and Nick Thaete); Historic Bartram's Garden/John Bartram Association (Joel T. Fry); Historical Society of Pennsylvania (Laura E. Beardsley, Kerry McLaughlin, and Daniel Rolph); Ivy Hill Cemetery Company (David G. Drysdale Jr.); *The Jewish Exponent*; Kensington History Project (Ken Milano); Kirk and Nice (John R. Rapp); Laurel Hill Cemetery Company (Bill Doran, Charles Davendish, and Leo Davendish); Library Company of Philadelphia (Sarah Weatherwax, Charlene Peacock, and Phil Lapsansky); John Milner Associates (Dan Roberts); Mother Bethel African Methodist Episcopal Church (Rev. Jeffrey N. Leath and Gary Reed); Mütter Museum,

College of Physicians of Philadelphia (Gretchen Worden); National Museum of Jewish History (Claire Pingel); Old St. Joseph's Church (Bobbye Burke); Pennsylvania Academy of the Fine Arts (Cheryl Leibold); Pennsylvania Trolley Museum (Edward Lybarger); Philadelphia Archdiocesan Historical Research Center; Philadelphia Jewish Archives Center (Eric Greenberg); Philadelphia Print Shop (Christopher Lane); *Philadelphia Tribune* (Johann Calhoun); Roosevelt Memorial Park (David Gordon); Roxborough-Manayunk-Wissahickon Historical Society (John Johnstone); Sisters of Saint Joseph (Sister Patricia Annas); Union League of Philadelphia (James Mundy); Urban Archives, Temple University Libraries (Evan Towle); and the Woodlands Cemetery Company (Sheree Cooper, Elizabeth Graf, and Philip Price Jr.).

Rita and Larry Arrigale hunted down cemeteries, offered technical and photographic advice, and provided home-cooked meals and emotional support. My thanks and love go to both of them.

My deepest gratitude goes to my partner and friend, Lawrence M. Arrigale, for acting as photographer, scanner, computer expert, editor, counselor, and fellow graveyard explorer. Without him, neither this book nor my life would be possible.

One
Colonial and Federal Graveyards

According to legend, the earliest European graveyard in the Philadelphia region was established in September 1646 by Swedish settlers at their church on Tinicum Island in the Delaware River. Before the year's end, the first corpse, that of Katerina Hansson, was buried there. The churchyard would later be swept away by the Delaware, and the bones of those interred there washed up on the shore, a harbinger of the future impermanence of Philadelphia graveyards.

In 1682, William Penn's surveyor-general, Thomas Holme, laid out the city of Philadelphia north of the original Swedish settlements. The 1,200-acre rectangle stretched between the Delaware and Schuylkill Rivers, bordered on the north by Vine Street and on the south by Cedar (South) Street. As the city's population grew from a few hundred settlers to over 2,000 inhabitants by 1700, so did the need for burial sites.

The proliferation of various graveyards reflected the diversity of religion, race, and income unique to early Philadelphia. The Quaker founding families were buried in the grounds of the Arch Street Meeting House with little ceremony and no markers. Members of the emerging Episcopalian oligarchy were buried with great ceremony and elaborate monuments, first at Christ Church, then at St. Peter's and St. Paul's. Other Protestant sects emerged, each with their own church and churchyard: First Baptist, First Moravian, Pine Street Presbyterian, St. Michael's Lutheran, and St. George's Methodist. As the city's Catholic and Jewish populations grew, they petitioned to establish their own burial sites, ensuring that they would rest in consecrated ground.

Those on the edge of society—enslaved and free African Americans, the poor, prisoners, and strangers—were consigned to the Potter's Fields located in the city's public squares. Families with enough land either in the city or on their country estates established private burial lots for their families and households. Many of these family lots lingered on into the early 20th century, when they were finally obliterated by Philadelphia's expanding neighborhoods.

In the early 1800s, the first nonsectarian cemeteries appeared. The Philadelphia, or Ronaldson's, Cemetery was established by James Ronaldson in 1827 on Ninth Street between Bainbridge and Fitzwater Streets. Open to all white Protestants, Philadelphia's first independent cemetery was an attractively landscaped space in a semirural setting with gravel paths for strollers. The gatehouse-chapel offered such amenities as a "bell room," where corpses could lie with one hand tied to a bell cord until the possibility of premature burial had passed. Many churches objected strenuously to Ronaldson's—not on religious grounds, but because they would lose their substantial burial and sexton's fees if it succeeded. Despite this opposition, Ronaldson's was Philadelphia's premier burial place until the rise of rural cemeteries a decade later.

Historian Charles Barker estimated that about 120 Colonial cemeteries existed in the original city of Philadelphia and in the adjoining districts of Northern Liberties and Southwark. Over 100 of these were religious, while the rest were public or family grounds. Fewer than 20 of these cemeteries have survived to the present day.

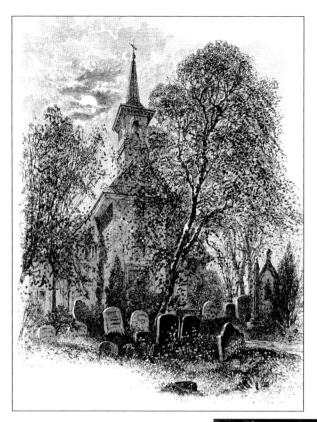

Gloria Dei (also known as Old Swedes' or Wicaco Church) is Philadelphia's oldest extant church and churchyard. In 1677, a log blockhouse in the settlement of Wicaco, south of the site later chosen for Philadelphia, was converted into a Swedish Lutheran church. In 1845, it became an Episcopalian congregation. The present church (shown here in 1876) was built in 1698–1700.

One of Gloria Dei's early pastors, Andrew Rudman, lies in a place of honor under the main aisle of the church. Among those interred in its churchyard are Alexander Wilson, author of *American Ornithology*. Wilson did not belong to the congregation, but wished to be buried "in some rural spot, sacred to peace and solitude . . . where the birds might sing over his grave." Today, the church still stands near the Philadelphia waterfront at Columbus Boulevard and Christian Street.

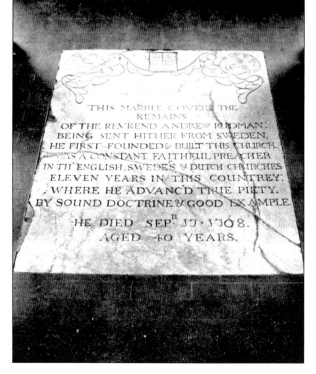

The Arch Street Friends Meeting House, at Fourth and Arch Streets (shown c. 1915), was built in 1804 on one of Philadelphia's first communal burial grounds. William Penn granted the property to the Quakers in 1701 for use as a burial place. Among the more than 20,000 Philadelphians buried here are James Logan, who was Penn's secretary and the owner of Stenton, and Charles Brockden Brown, the author of *Wieland*, the first American novel.

The early Friends forbade tombstones. By 1800, markers began to appear on Quaker graves with the names or initials of the deceased and their birth and death dates. This marker for Joseph Parker Norris was probably once within the Arch Street Meeting House grounds. Today, it lies in a parking lot. Ironically, Norris was one of the first trustees of now-vanished Ronaldson's Cemetery in South Philadelphia (see page 116). (L.M. Arrigale.)

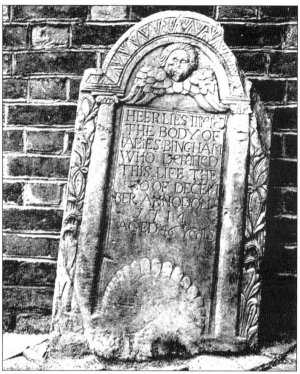

Christ Church was founded in 1695 as the first Anglican church in Pennsylvania. Between 1727 and 1754, its current Georgian structure was erected at Second and Market Streets. Many of the church's wealthy parishioners were buried in the surrounding graveyard. Among them was landowner James Bingham, whose grave is shown here. Its elaborate carving and position next to the church wall illustrate his elevated status. (Christ Church Preservation Trust.)

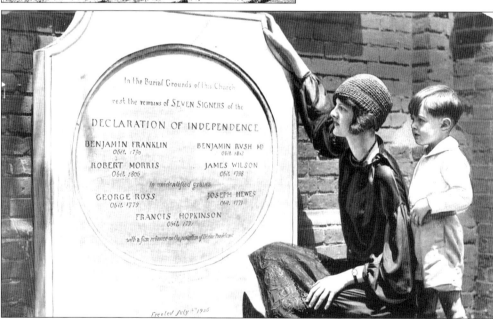

Many early American leaders worshiped at Christ Church, including George Washington and John Adams. Six signers of the Declaration of Independence—Benjamin Franklin, Robert Morris, George Ross, Benjamin Rush, James Wilson, Joseph Hewes, and Francis Hopkinson—are buried in its churchyard or in the burial ground at Fifth and Arch Streets. In 1926, a marble memorial tablet honoring their memory was erected at "the Nation's Church." (Urban Archives, Temple University.)

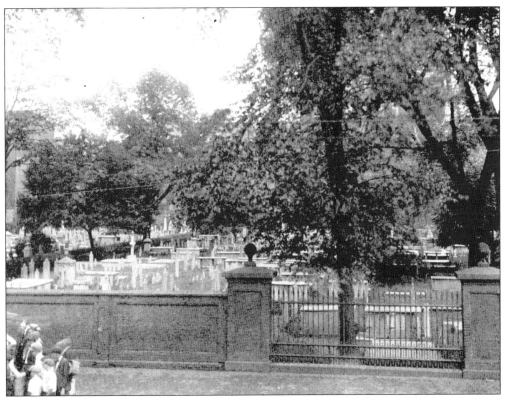

By 1719, the yard surrounding Christ Church was full. A new burial ground was purchased at Fifth and Arch Streets, "on the outskirts of town." Christ Church Burial Ground is the final resting place of over 4,000 Philadelphians, including Dr. Benjamin Rush, Dr. Phillip Syng Physick, Francis Hopkinson, Commo. William Bainbridge, and many others. After the 1976 bicentennial, Christ Church closed the historic site because of the fragile condition of the gravestones. Recently, the Christ Church Preservation Trust raised $400,000 to restore many of the major monuments. In April 2003, Christ Church Burial Ground reopened to the public for the first time in 25 years. These photographs show the ground as it appeared c. 1910 (above, looking south), and as it looks today (below, looking west toward Fifth Street). (Above: Germantown Historical Society; below: Tom Crane Photography.)

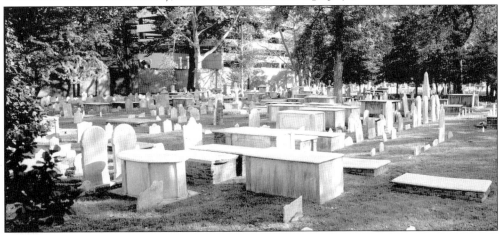

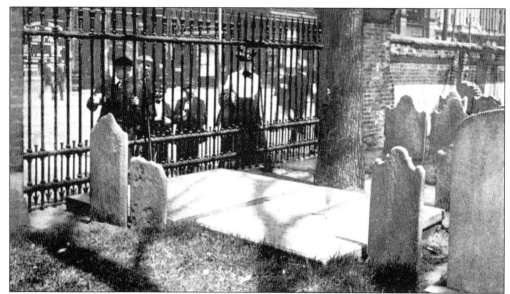

The most famous resident of Christ Church Burial Ground is Benjamin Franklin (1706–1790), author, inventor, scientist, postmaster, printer, diplomat, and patriot. He lies next to his wife, Deborah, and near his son Francis, daughter Sarah, and son-in-law Richard Bache. In 1858, the brick wall by his grave was replaced with a gate to allow passersby to view his resting place (above). It also allowed children to toss pennies on the stone in a time-honored tribute to the author of the maxim, "A penny saved is a penny earned." For many years, Franklin's birthday, January 17, was a holiday in Philadelphia. In the 1926 photograph below, members of the Poor Richard Club (an association for journalists and advertisers) place a wreath on his grave, while Franklin's great-great-great-grandson, Franklin Bache Huntington, portrays his ancestor. (Below: Historical Society of Pennsylvania.)

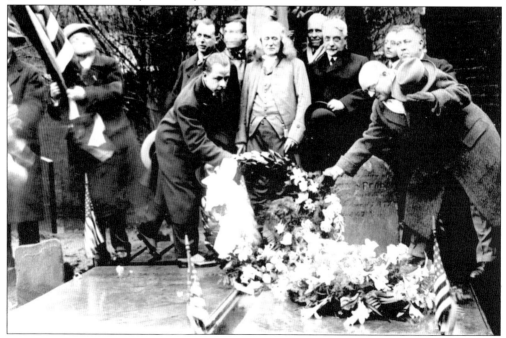

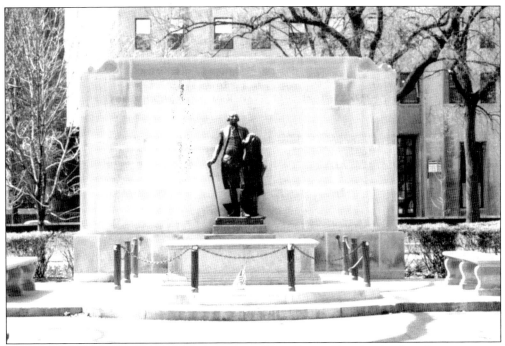

While Philadelphia's Colonial elite were buried at Christ Church, the less fortunate were buried in the city's public squares. In 1706, Southeast Square was designated as the Strangers' Burial Ground, a resting place for early Catholics, African American slaves and freemen, yellow fever victims, and over 2,000 Revolutionary War soldiers. Burials ceased in the early 19th century, and the site was renamed Washington Square in 1825. In 1954, the skeleton of a Colonial soldier was unearthed, then reinterred in the Tomb of the Unknown Soldier of the Revolution (above). In 2002, the square was placed under the supervision of the National Park Service. The watercolor by David Kennedy below shows Northwest Square (today Logan Circle) still in use as a Potter's Field in 1836. The view looks south from Vine Street toward Market Street. (Above: L.M. Arrigale; below: Historical Society of Pennsylvania.)

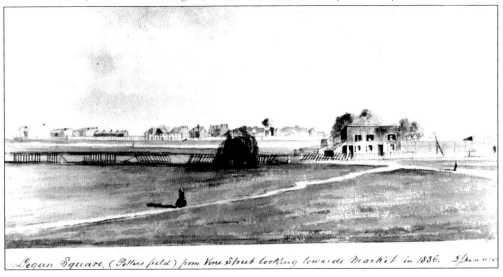

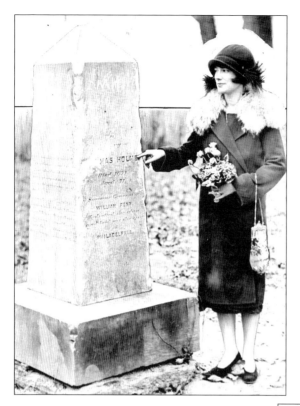

Many affluent families established family burial lots on their estates. Thomas Holme, William Penn's surveyor-general, was buried on his Well Spring Plantation (today Holmesburg). It was later named the Crispin Cemetery after his son-in-law, Silas Crispin. In this 1924 photograph, Holme descendant Elizabeth Crispin indicates the vandalized monument to her ancestor. In 1929, Philadelphia established Holme-Crispin Park, including the cemetery, as part of Pennypack Park. (Urban Archives, Temple University.)

The Say Burying Ground, on Third Street between Arch and Market Streets, was the resting place of wealthy physicians and abolitionists Thomas Say (1709–1796) and Benjamin Say (1775–1813), grandfather and father of naturalist Thomas Say, respectively. The small space was used for burials as early as 1721, but was abandoned c. 1870. Nearly all private family graveyards in Philadelphia were obliterated by the early 20th century. (Historical Society of Pennsylvania.)

At a time when the public celebration of Catholic Mass was forbidden in Britain and America, Fr. Joseph Greaton established St. Joseph's Church on Willings Alley in 1733. Between 1733 and 1759, St. Joseph's churchyard (shown in an early Frank Taylor sketch) was the only Catholic cemetery in Philadelphia. Before then, Catholics were buried in the Strangers' Burial Ground (Washington Square). In 1759, the congregation established a second burial ground on Fourth Street between Spruce and Locust.

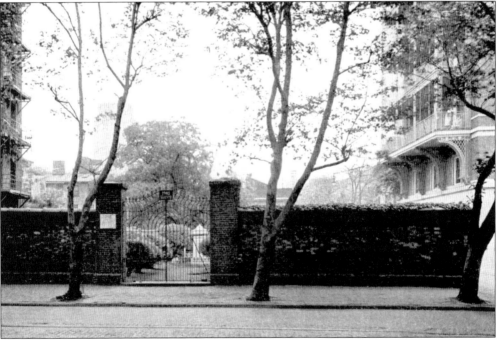

In 1738, Jewish merchant Nathan Levy petitioned the Penn family for "a small piece of ground" as a sanctified burial space for his dead child. Two years later, Levy purchased a larger lot on Spruce Street above Eighth, which became the cemetery of Philadelphia's early Jewish community. According to legend, British soldiers executed deserters against the cemetery's brick wall (seen above c. 1920) during the Revolutionary War.

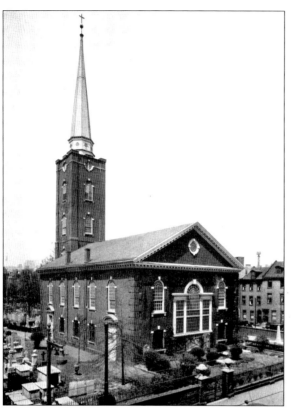

St. Peter's Church (shown at the left c. 1910) opened on Pine Street in 1761 to serve the Anglican residents of Society Hill. Its churchyard holds painter Charles Willson Peale and his artist son Raphaelle; Nicholas Biddle, president of the Second Bank of the United States; Commo. Stephen Decatur, hero of the Battle of Tripoli in 1804; and the chiefs of eight Indian tribes, who died of smallpox while on a treaty mission to Philadelphia in 1793. George M. Dallas, who served as the vice-president of the United States under President Polk and gave the Texas city its name, also lies there. In the 1936 publicity shot below, Texas Rangerettes Mary Rooks and LaVee Killman help Mayor Joseph H. Moore place a wreath on the Dallas grave under the watchful eye of Dallas descendants and the rector of St. Peter's. (Below: Urban Archives, Temple University.)

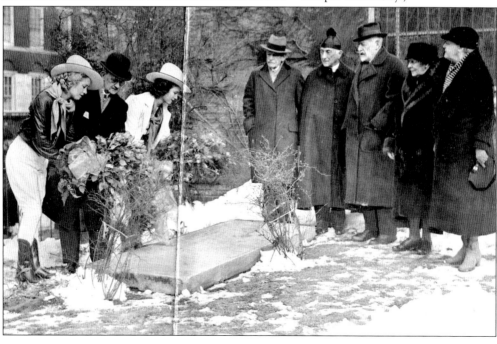

War of 1812 veteran Charles Ross (1772–1817) lies at the Old Pine Street Presbyterian Church, founded in 1768 at Fourth and Pine Streets. His grave, shown c. 1900, featured bronze decorations of the headgear and insignia of the First Troop Philadelphia City Cavalry, of which Ross was the seventh captain. Old Pine's churchyard also holds the ashes of Eugene Ormandy (1899–1985), conductor of the Philadelphia Orchestra from 1938 to 1990.

St. George's United Methodist Church, located at Fourth Street above Race since 1769, is the oldest Methodist church in continuous existence in the world. Between 1795 and 1833, its burial ground was located on Crown (now Crease) Street. After its second burial ground on Christian Street was sold in 1847, the Methodist dead were moved to St. George's and placed beneath a brick hallway. (L.M. Arrigale.)

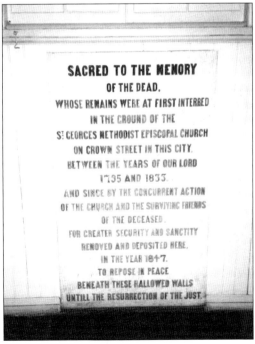

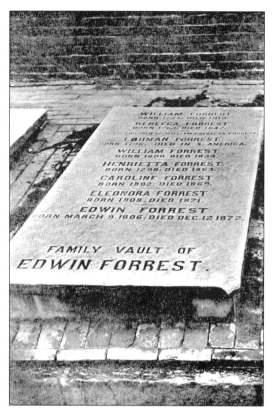

Noted actor Edwin Forrest (1806–1872), who left a bequest to establish an actors' retirement home that still exists, lies in rest at St. Paul's Episcopal Church on South Third Street. The entrance to his family vault is shown here c. 1910. St. Paul's, which opened in 1761, attracted an affluent and worldly congregation, many of whom were buried in vaults along the church walls. Inactive since the early 20th century, the church building now houses the Episcopal Community Services offices.

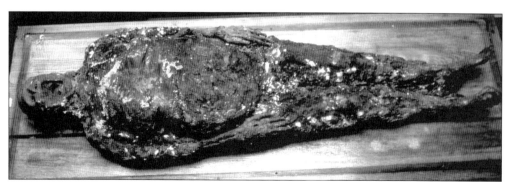

Resting in peace proved to be an elusive dream for this early-19th-century woman, removed from an unknown churchyard in the 1870s. Her body fat had turned into adipocere, a soaplike substance that arrests decay. Today, the saponified woman is one of the star attractions at Philadelphia's Mütter Museum. The saponified man buried next to her now belongs to the Smithsonian Institution. (Mütter Museum, College of Physicians of Philadelphia.)

Two
LAUREL HILL CEMETERY

By the 1830s, a new concept in burial sites had reached America: the rural or garden cemetery. The first rural cemetery, Père-Lachaise, had been established in Paris in 1804 as an alternative to the city's overcrowded and unhygienic graveyards. A product of the period's Romantic philosophy, rural cemeteries attempted to beautify death with picturesque landscapes filled with magnificent monuments. By placing the dead far outside city limits, rural cemeteries were also expected to reduce the epidemics thought to be caused by foul emanations arising from urban churchyards. In 1831, America's first rural cemetery, Mount Auburn, was founded in Cambridge, Massachusetts.

John Jay Smith, a librarian and editor with interests in horticulture and real estate, was determined to make Philadelphia the home of the second rural cemetery in America. Distressed by the watery interment of a young daughter in the Arch Street Meeting House burial ground, Smith resolved that "Philadelphia should have a rural cemetery on dry ground, where feelings should not be harrowed by viewing the bodies of beloved relatives plunged into mud and water." He gathered a group of investors and acquired a country estate nearly four miles north of the city, overlooking the Schuylkill River. At this distance, Laurel Hill was seen as safe from the urban expansion that had already engulfed Ronaldson's Cemetery.

In the struggle for survival following the financial panic of 1837, Laurel Hill's managers decided to relocate famous Revolutionary figures to the cemetery. Among those reburied at Laurel Hill was Continental Congress secretary Charles Thomson (whose removal sparked a scandal); Declaration of Independence signer Thomas McKean; Hugh Mercer, hero of the Battle of Princeton; and director of the U.S. Mint David Rittenhouse. By 1844, over 900 families owned lots at Laurel Hill, and over 30,000 visitors traveled there each year to enjoy its picturesque beauty. Soon, the managers acquired two adjacent estates, enlarging Laurel Hill to its current 95 acres.

During and after the Civil War, Laurel Hill became the final resting place of hundreds of military figures, including 40 generals. Laurel Hill also became the favored burial place for many of the "new men" who dominated Philadelphia politics and business after the Civil War, including Matthias W. Baldwin, founder of the Baldwin Locomotive Works; Henry Disston, owner of the largest saw manufactory in the world; and Peter A.B. Widener, who controlled Philadelphia's trolley lines. Many of these men are buried in elaborate mausoleums along Millionaire's Row, as separate from old-line Philadelphia in death as they were in life.

The Friends of Laurel Hill Cemetery was founded in 1976 by John Jay Smith descendants Jane and Drayton Smith, and author and historian John Francis Marion. Since then, the Friends of Laurel Hill Cemetery has raised funds to restore hundreds of monuments and has been instrumental in the cemetery's placement on the National Register of Historic Places and designation as a National Historic Landmark. Today, Laurel Hill once again attracts thousands of visitors each year to admire its beautiful landscape and elaborate memorials.

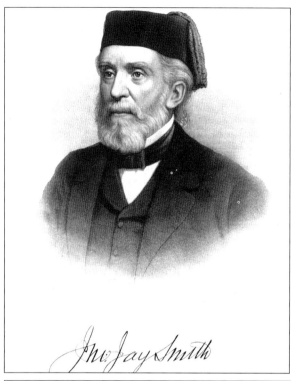

John Jay Smith (1798–1881) was a Quaker entrepreneur, editor, horticulturist, librarian, and a descendant of James Logan, secretary to William Penn. His unhappy experience with the urban burial of a young daughter convinced him that Philadelphia needed a "suitable, neat, orderly" burial place. In 1835, he joined forces with former mayor Benjamin W. Richards, Frederick Brown, William Strickland, and Nathan Dunn to plan the creation of Philadelphia's first rural cemetery. (The Burlington Smiths.)

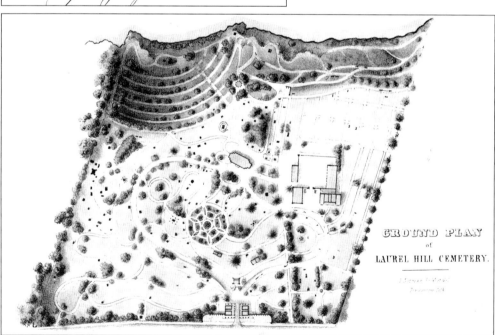

Smith and his group considered several sites before selecting the estate of the late Joseph Sims on the east bank of the Schuylkill River, over three miles above the city's northern boundary. In 1836, the group organized as the Laurel Hill Cemetery Company. This 1844 map of the cemetery shows many features of the Sims estate still intact, including the mansion located above the formal Medallion Garden, at the top center. (James Hill Jr.)

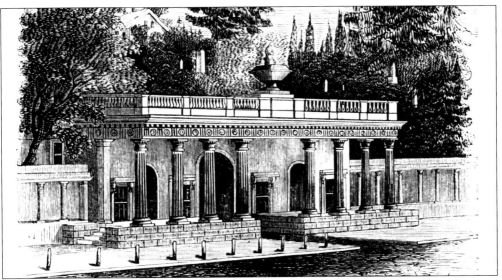

Philadelphia's leading architects, William Strickland and Thomas Ustick Walter, submitted designs for the layout and architecture of Laurel Hill. The commission, however, went to a young Scottish immigrant named John Notman (1810–1865). Shortly afterward, Strickland resigned from the cemetery board. Notman's layout for Laurel Hill (see page 22) followed the topography of the site and incorporated such natural features as a string of terraces descending to the river. For the gatehouse (above), Notman designed a massive Roman arch framed by an imposing classical colonnade and topped by a large ornamental urn. Other cemetery buildings, such as the chapel (below), were designed in the newly popular Gothic Revival style. While Notman's gatehouse still stands on Ridge Avenue, the chapel was demolished in the 1880s to make room for burial lots. (James Hill Jr.)

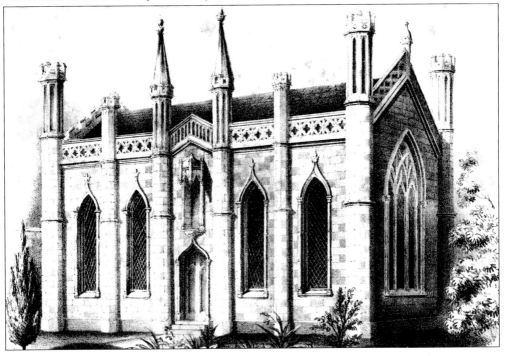

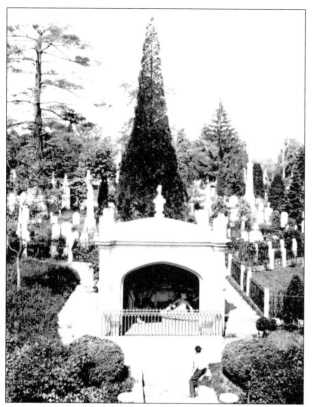

Laurel Hill's managers purchased a statuary group known as Old Mortality from the Scottish sculptor James Thom and placed it in the central courtyard. Based on a tale by Sir Walter Scott, the group shows Scott talking to Old Mortality, an elderly man who traveled through the Highlands, recarving weathered gravestones. Old Mortality was the first thing seen by visitors to Laurel Hill after passing through the gatehouse. The statues not only reminded them that they were on a similar mission of memory but assured them that they were in a cultured and established environment. The stereo view photograph (left) shows the Old Mortality shelter c. 1870, and the 1920s photograph below shows Walter Scott on the left and Old Mortality atop a gravestone, observed by a pony and a bust of James Thom. (Laurel Hill Cemetery Company.)

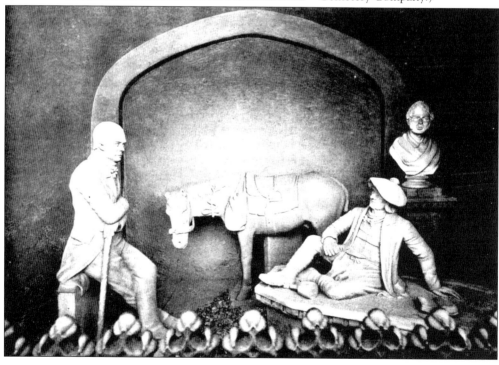

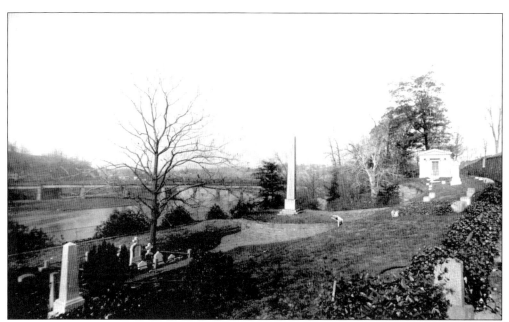

To attract visitors and customers, Laurel Hill relocated famous Revolutionary figures, such as Charles Thomson (1729–1824), secretary of the Continental Congress from 1774 to 1789. Laurel Hill's managers removed him from his grave at Harriton, his wife's Bryn Mawr estate, without the permission of his wife's family, touching off a scandal that lasted for decades. This c. 1910 photograph shows the obelisk erected over Thomson's grave. (Laurel Hill Cemetery Company.)

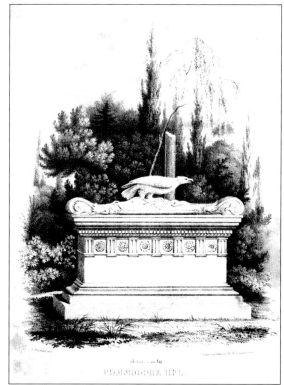

Commo. Isaac Hull (1773–1843), captain of the USS *Constitution*, or Old Ironsides, scored a dramatic naval victory over the British frigate *Guerriére* in August 1812. He was buried under a copy of the sarcophagus of the Roman general Scipio, topped by a bald eagle guarding the American flag. Hull's selection of Laurel Hill as his final resting place signaled the acceptance of the cemetery by Philadelphia's elite. (James Hill Jr.)

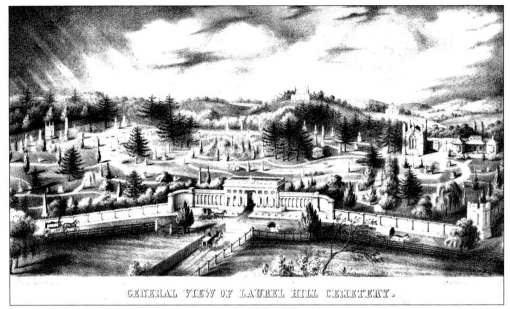

GENERAL VIEW OF LAUREL HILL CEMETERY.

By the 1840s, Laurel Hill had become one of Philadelphia's "lions," or star attractions. John Jay Smith planted 800 trees and shrubs, creating the lush landscape seen in the 1844 print above. The preferred way of reaching Laurel Hill was to take a steamboat from a pier near the waterworks, traveling up the Schuylkill River to the Laurel Hill landing (below). The number of visitors was so great that the managers began issuing admission tickets. On Sunday—the one free day for most working people—the cemetery was open only to lot holders and their families. This selectivity extended to the cemetery's clientele, who remained almost exclusively white Protestants well into the 20th century. The managers even discouraged unmarried people from purchasing lots, so that Laurel Hill would be a family cemetery. (The Burlington Smiths.)

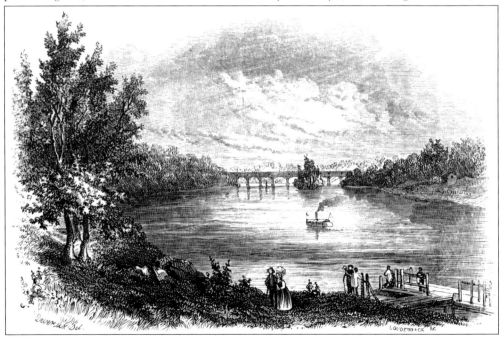

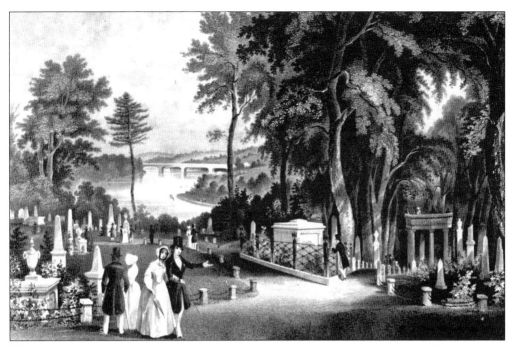

This 1840s print shows elegantly dressed promenaders enjoying Laurel Hill's elaborate monuments, its summer pavilion (far right), and the view of Philadelphia in the distance. Engravers usually exercised creative license for prints like this, gathering Laurel Hill's most elegant monuments into one imaginary landscape. Years before Philadelphia had a public park, art museum, or arboretum, Laurel Hill Cemetery served in all three capacities. (James Hill Jr.)

Elisha Kent Kane (1820–1857), a world-famous Arctic explorer and author, was buried in his family's hillside vault after lying in state at Independence Hall. Kane's romance with spiritualist Margaret Fox scandalized Philadelphia; he once promised her that the two of them would rest together in this tomb. Margaret, repudiated by Kane's family after his death, renounced spiritualism and took to drink. Today, she lies in an unmarked grave in Brooklyn. (Laurel Hill Cemetery Company.)

Philadelphia's crucial involvement in the Civil War is reflected at Laurel Hill, where 40 Civil War–era generals rest in peace. Among them is the only Confederate general buried in Philadelphia, John Clifford Pemberton (1814–1881). Pemberton, a Philadelphia native married to a Virginia woman, opted to fight for the South. He served as military commander of Vicksburg, surrendering it to U.S. Grant after a long siege on July 4, 1863. Pemberton later returned to the Philadelphia area and died on his Penllyn farm in 1881. (Michael Brooks.)

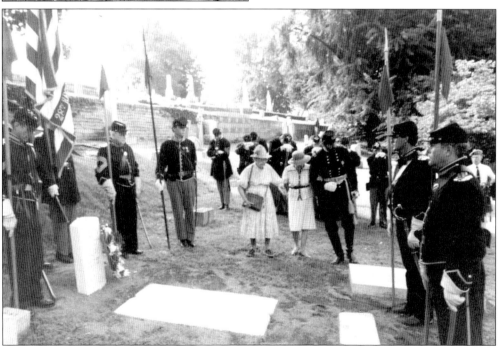

Architect Frank Furness (1839–1912) served as captain in the 6th Pennsylvania Cavalry during the Civil War and won the Congressional Medal of Honor for his actions at the battle of Trevilian Station, Virginia, where he carried a box of ammunition through enemy fire. In July 1990, two of Furness's descendants, Mrs. Henry L. Savage and Mrs. Joseph B. Townsend, attended a ceremony commemorating a new grave marker. (Andy Waskie, Ph.D.)

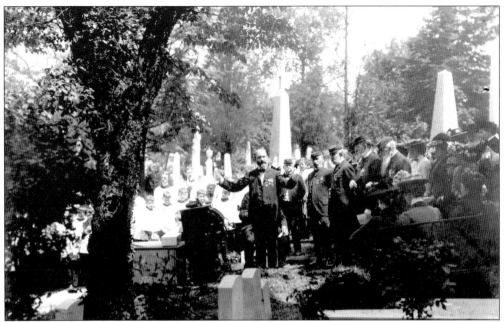

Trained as an engineer, George Gordon Meade (1815–1872) was named brigadier general at the start of the Civil War. On June 28, 1863, he was placed in command of the Army of the Potomac, shortly before the battle of Gettysburg. After three days of bloody fighting, Meade's men forced Robert E. Lee's Army of Northern Virginia to retreat. Meade retired to Philadelphia after the war ended. His 1872 funeral was attended by President Grant, General Sherman, the governor of Pennsylvania, and hundreds of veterans. For many years, G.A.R. Post No. 1 held a memorial service at Meade's grave on Memorial Day, as shown by these two photos from May 1901. Today, the Meade Society perpetuates the tradition with a graveside ceremony and champagne toast on Meade's birthday, December 31. (Archives of the Union League of Philadelphia.)

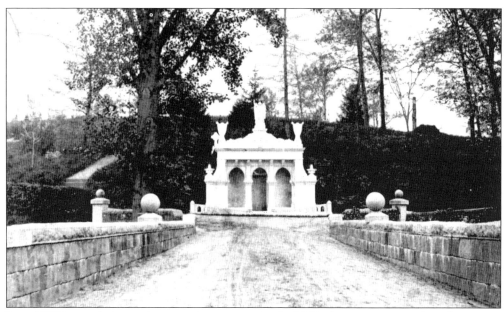

Laurel Hill's popularity made expansion a necessity. In 1844, the managers purchased an estate half a mile south of the cemetery and named it South Laurel Hill. In 1863, the middle property was acquired and named Central Laurel Hill. With this purchase, the cemetery reached its current size of roughly 95 acres. Shown above is the bridge built over Hunting Park Avenue to connect South and Central Laurel Hill, looking north. The Benson mausoleum, erected in 1868, was one of the first monuments in Central Laurel Hill. The Warner lot (shown below c. 1910) is an example of the elaborate family plots that soon filled Central Laurel Hill. The monument on the far right, with a mysterious woman lifting a sarcophagus lid to release the spirit within, is by Alexander Milne Calder, creator of the statuary on Philadelphia City Hall. (Laurel Hill Cemetery Company.)

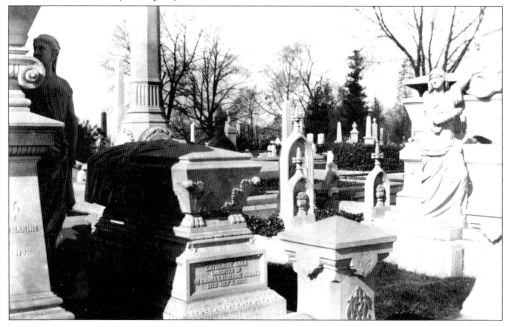

Millionaire's Row is lined with the mausoleums of the industrialists and financiers who controlled Philadelphia after the Civil War. Shown here c. 1930 is the family mausoleum of Henry Disston (1819–1878), a poor English immigrant who later established the Disston Saw Works in Tacony, once the leading saw manufacturer in the world. His mausoleum, the largest monument in Laurel Hill, cost $60,000 to erect in 1878. (Laurel Hill Cemetery Company.)

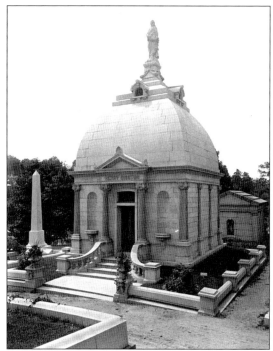

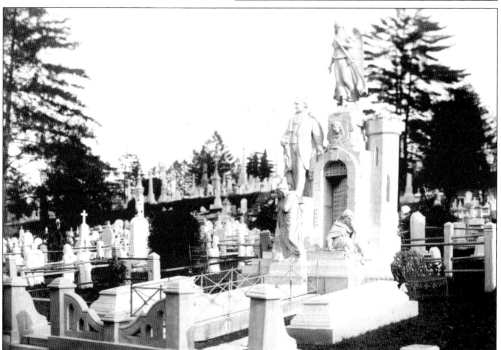

William James Mullen was a manufacturer who served as the prisoner's agent at Moyamensing Prison. Obsessed with being remembered, he commissioned a grandiose monument that shows him next to the open prison door, surrounded by symbolic figures mourning his death, including the archangel Gabriel and the face of Christ. Mullen was so proud of his monument that he exhibited it at the 1876 centennial exhibition. (Laurel Hill Cemetery Company.)

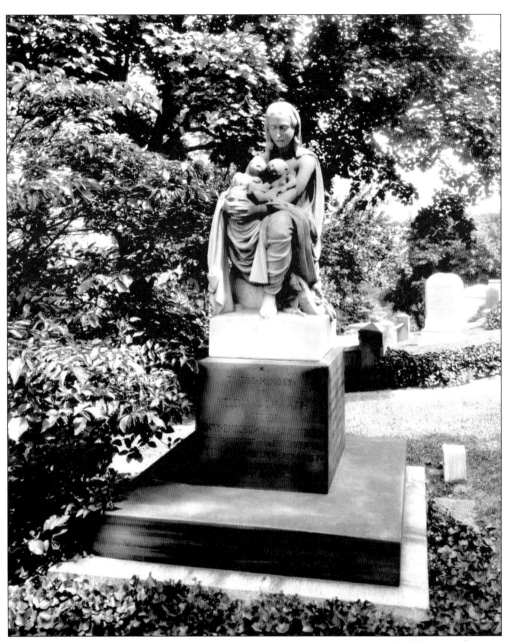

One of Laurel Hill's most poignant monuments, overlooking the Schuylkill River, shows a weeping woman clutching two babies. It was carved by a Polish sculptor named Henry Dmochowski-Saunders (1810–1863), whose busts of Koscuiszko and Pulaski are in the U.S. Capitol. It represents his wife, the noted pianist Helena Schaaff (1823–1857), and their two children. Their first child was stillborn; two years later, the second child also died during birth, as did Helena. The distraught widower spent a year and a half carving the memorial to his dead family. Later, Dmochowski returned to Europe, where he was killed in 1863 while leading an uprising for Polish freedom against the Russian army. For many years, one of Laurel Hill's urban legends was that the mother looked on the spot in the river where she and her babies drowned during a boating accident. (Laurel Hill Cemetery Company.)

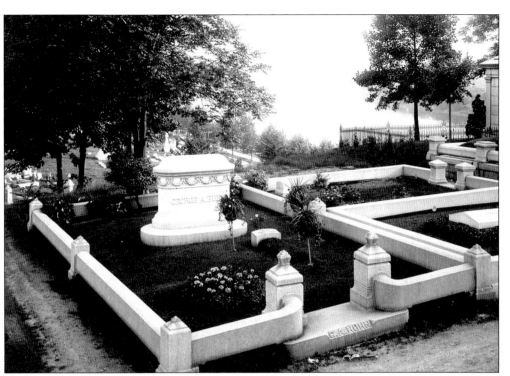

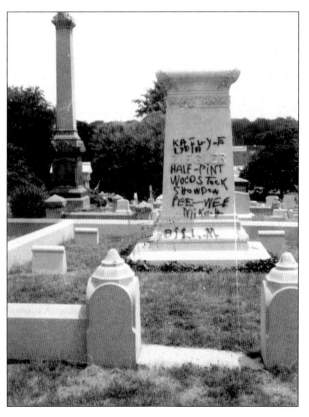

The photograph above shows the idealized Laurel Hill of the early 20th century, with manicured lawns and immaculate grave sites. By this time, however, its star had begun to fade. Hemmed in by Fairmount Park and the city, the cemetery had no room to expand. Philadelphians began to favor suburban sites, including West Laurel Hill, a sister cemetery in Lower Merion founded by John Jay Smith in 1874. Some bodies were disinterred and removed to West Laurel Hill, including that of hat manufacturer John Stetson. The Great Depression and Philadelphia's post–World War II decline dealt further blows to the cemetery. By the time the photograph on the right was taken in 1970, Laurel Hill was the victim of neglect, vandalism, and crime. Many of its graves were ransacked for their artwork. (Above: H.C. Wood Memorials, Harvard C. Wood III; right: Laurel Hill Cemetery Company.)

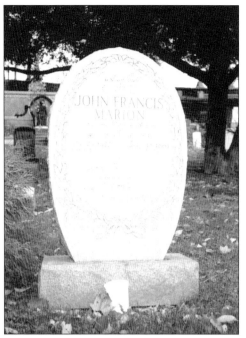

In 1976, the Friends of Laurel Hill Cemetery was created to preserve the cemetery and to raise awareness of its historical importance. John Francis Marion (1922–1991), one of the organization's founders, gave lectures, wrote articles, and helped to initiate the Halloween tours that are still an annual tradition. In 1991, he was buried in a lot donated by Laurel Hill in gratitude for his work, under a tombstone of his own design (shown on the left, with a luminary in front from a recent Halloween tour). The Friends of Laurel Hill Cemetery has been instrumental in repairing hundreds of notable graves, restoring the gatehouse, and having Laurel Hill listed on the National Register of Historic Places and named a National Historic Landmark. On any given day, Laurel Hill is busy with visitors, tour groups, researchers, and historical reenactors, such as those shown below at a recent Memorial Day ceremony. (Left: Carolyn Cades; below: Andy Waskie, Ph.D.)

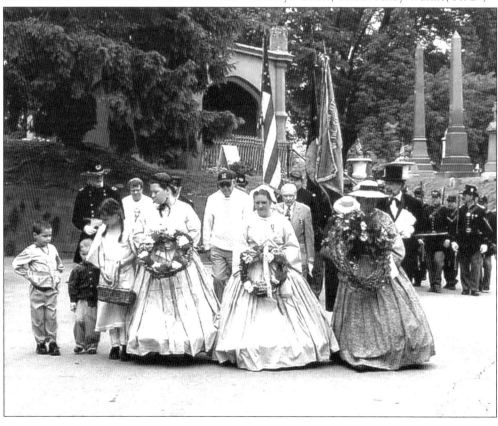

Three
THE WOODLANDS

The Woodlands, like Laurel Hill, is a leading example of Philadelphia's 19th-century rural cemeteries. Originally, the Woodlands site was part of a 250-acre tract in Blockley Township in West Philadelphia, purchased by attorney Andrew Hamilton in 1734. Hamilton successfully defended New York printer Peter Zenger against a charge of seditious libel brought by the British Crown, establishing important precedents for freedom of speech and the press. As attorney for the Penn family, Hamilton amassed considerable wealth and large land holdings in and around Philadelphia.

Hamilton's grandson, William, inherited the Woodlands estate in 1747. After a two-year stay in England, William returned to America and erected one of the country's finest neoclassical Federal mansions in 1788–1789. A talented botanist, he collected many rare plants at the Woodlands, including the earliest known ginkgo and Lombardy poplar trees in the United States. After his death in 1813, his heirs sold off much of the property for residential development. In the 1830s, John Jay Smith and his associates considered the Woodlands as the site for their planned cemetery but settled on Laurel Hill instead.

In 1840, the Woodlands Cemetery Company purchased the mansion and remaining property. Hamilton's gardens, sloping down to the Schuylkill River, provided the perfect picturesque setting for a rural cemetery. The Federal mansion was turned into an office and chapel, and the icehouse became the receiving tomb. The Woodlands Cemetery got off to a slow start because of the lingering depression following the Panic of 1837, and because of loans the managers took out to purchase the property. The first burial did not take place until March 28, 1845. The following month, the remains of Commo. David Porter were transferred from the Naval Asylum burial grounds, providing the Woodlands with its first celebrity.

By the time of the Civil War, the Woodlands' survival was assured, and it rivaled Laurel Hill in attracting Philadelphia's elite. Among those buried there are financiers Francis Drexel, Anthony Biddle, and Edward Stotesbury; artists Rembrandt Peale and Thomas Eakins; and architects Paul Philipe Cret and Wilson Eyre Jr. Because of its proximity to the hospital and medical school of the University of Pennsylvania, the Woodlands was particularly popular with physicians, such as Samuel D. Gross, John Ashhurst, Jacob Mendez DaCosta, and Horatio Charles Wood.

Today, the Woodlands Cemetery Company operates as a nonprofit organization. The Friends of the Woodlands, working with the cemetery company and the University City Historical Society, is currently restoring both the mansion and cemetery. Recently, the site was designated the Woodlands Heritage National Recreation Trail by the National Park Service of the United States Department of the Interior. Surrounded by the incessant activity of the University of Pennsylvania, the Woodlands continues to offer a green and peaceful oasis, where, in the words of an early advertisement, "the decaying bodies of the dead may securely moulder into kindred dust, with an abundant vegetation and free winds to absorb and dissipate all noxious effluvia."

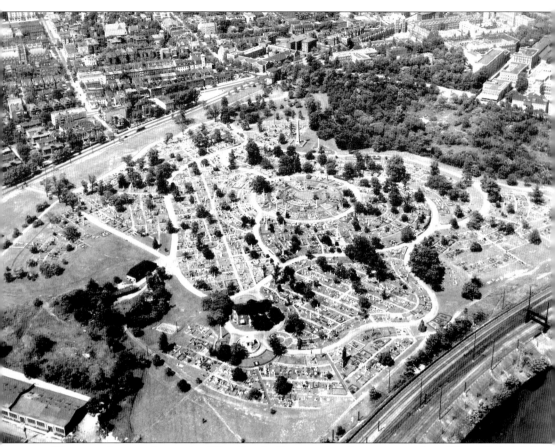

This aerial view shows the Woodlands Cemetery and its surrounding West Philadelphia community in 1932. The Hamilton mansion is in the lower left center, with the Drexel mausoleum directly below it. In the lower right are the tracks of the Pennsylvania Railroad running along the Schuylkill River. Along the top of the photograph, from left to right, are the Hamilton Terrace neighborhood, the University of Pennsylvania, and the University of Pennsylvania Medical School. Much of the open space in the upper right of the photograph was later sold and is now the site of the veterans hospital. (Woodlands Cemetery Company of Philadelphia.)

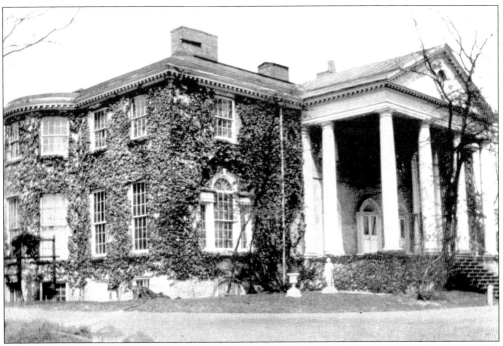

William Hamilton, grandson of the original owner of the Woodlands estate, was determined to, in his words, "make it smile in the most useful and beautiful manner." The graceful Federal mansion he erected in 1788–1789 (seen here c. 1920) was originally covered in white stucco scored to resemble stone. Hamilton's gardens displayed his unique botanical collection, praised by Thomas Jefferson, George Washington, and John and William Bartram.

In 1840, a group of investors purchased the Woodlands and its remaining property for a rural cemetery. John McArthur Jr., later the architect of Philadelphia City Hall, designed a massive arched gateway on Woodland Avenue (shown above in 1929). In 1936, the entrance was torn down when University Avenue was created, and a simpler entrance designed by Paul Cret was placed further west on Woodland Avenue. (Urban Archives, Temple University.)

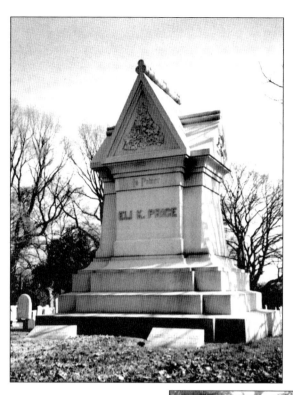

Eli Kirk Price (1787–1884), one of the Woodlands' founders, helped to create modern Philadelphia. As a state senator, he sponsored the 1854 Consolidation Act, increasing the city from 1,200 acres to 122 square miles. Influenced by Philadelphians' use of the Woodlands as a retreat, Price helped found the Fairmount Park Commission in 1867 and served as chairman until his death. His family is still instrumental in the operation of the cemetery. (L.M. Arrigale.)

One of the first burials at the Woodlands was that of Commo. David Porter (1780–1843). Porter commanded the frigate *Essex* during the War of 1812, acted as a commander-in-chief of the Mexican navy, and served as the U.S. minister at Constantinople until his death. Originally buried at the United States Naval Asylum, Porter's remains were transferred to the Woodlands on April 10, 1845. (Library Company of Philadelphia.)

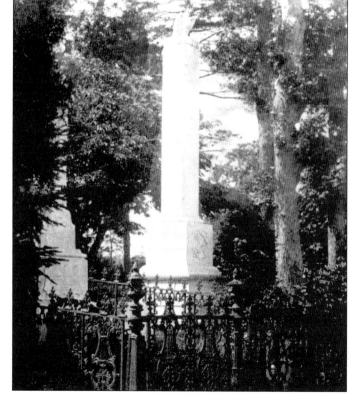

William H. Moore, a manager of the Woodlands, erected a soaring Gothic monument for his family lot, with statues representing the Christian virtues of Faith, Hope, Charity, and Mercy. Moore was a prominent undertaker at Arch and Fifth Streets and developed the innovation of preconstructing coffins in different sizes and keeping them on hand, rather than building them individually upon the death of a customer. (L.M. Arrigale.)

In an era of limited medical knowledge, Dr. David Jayne (1799–1866) built a fortune from such patent medicines as Indian Expectorant and Tonic Vermifuge. By 1848, his business was so successful that he hired Thomas Ustick Walter to design a 10-story Gothic office building at 242–244 Chestnut Street. For decades, *Dr. Jayne's Medical Almanac* was a fixture in Philadelphia homes; over 500 million copies were distributed between 1843 and 1930. (L.M. Arrigale.)

The Saunders obelisk marks the grave of Courtland Saunders, captain in the 118th Pennsylvania Volunteers, who fell in battle at Shepperdstown Ford, Virginia, on September 20, 1862, at age 21. Also buried there is his father, Presbyterian minister Ephraim Dod Saunders, who helped to found the Presbyterian hospital in 1872 as a memorial to his son. Today, the hospital is part of the University of Pennsylvania Health System. (L.M. Arrigale.)

David Bell Birney (1825–1864) was a Philadelphia lawyer until the Civil War, when he recruited the 23rd Pennsylvania Infantry and became its Lieutenant Colonel. Although court-martialed at the battle of Fair Oaks, he was restored to command and served with distinction at Fredericksburg, Chancellorsville, and Gettysburg, rising to the rank of major general. He contracted malaria in 1864 and died in Philadelphia at the age of 39. (L.M. Arrigale.)

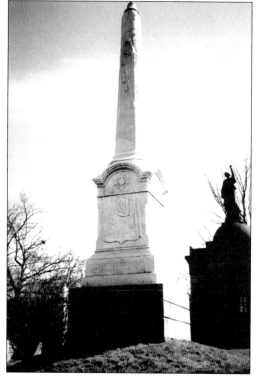

First Lieutenant John T. Greble (1834–1861) was the first West Point graduate (class of 1854) to die in the Civil War, at the battle of Big Bethel, Virginia, on June 10, 1861. The officer's body lay in state at Independence Hall before being taken to the Woodlands, where he was buried in one of the newly fashionable "cradle" graves, with a space for plantings in the center. (James Hill Jr.)

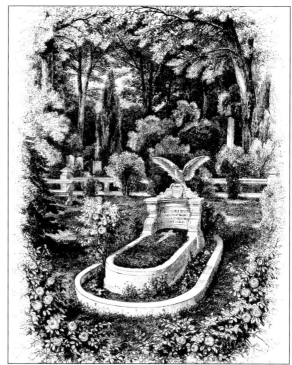

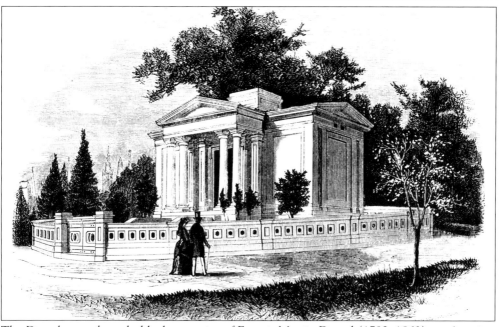

The Drexel mausoleum holds the remains of Francis Martin Drexel (1792–1863), an Austrian immigrant who founded Drexel and Company, Philadelphia's leading brokerage firm for decades. Also buried there are his sons, including Anthony Joseph Drexel, founder of Drexel University and financial advisor to President Grant. Drexel's granddaughter, Saint Katharine Drexel, canonized in 2000, is interred in the crypt of the Motherhouse Chapel of St. Elizabeth's Convent near Bensalem. (James Hill Jr.)

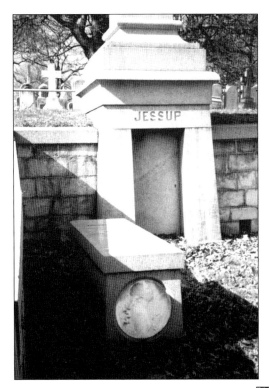

As a young man, Augustus Jessup accompanied a government expedition to explore the Rocky Mountains in 1819. He later formed the Jessup and Moore Paper Company with son-in-law Bloomfield Moore (also buried in the Jessup lot). Clara Jessup Moore, Augustus's daughter and Bloomfield's wife, lost a fortune in one of Philadelphia's greatest frauds: John Worrell Keely's "Hydro-Pneumo-Pulsating-Vacuo-Motor," which Keely claimed would power a train across the country on a quart of water. (L.M. Arrigale.)

Born in Philadelphia, Frank Stockton (1834–1902) was a prolific author and an assistant editor of the popular children's periodical *St. Nicholas Magazine*. Although his collected works ran to 23 volumes, he is remembered today primarily for one short story, "The Lady or the Tiger?," a tale whose enigmatic outcome has been debated in English classes for decades. Stockton is buried with his wife, Mary Tuttle Stockton. (L.M. Arrigale.)

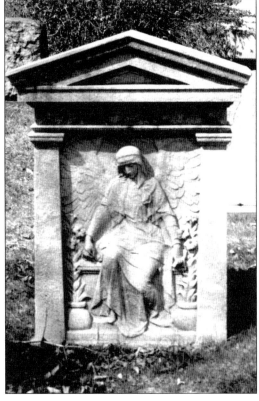

The Woodlands was popular with clergymen, such as Stephen H. Tyng Sr. (1800–1885), a conservative evangelical Episcopalian minister, pastor at Philadelphia's Church of the Epiphany, and one of the founders of the Pennsylvania Society for Evangelizing the Jews. Many urban churches, including Tyng's Church of the Epiphany, arranged to have their dead parishioners removed to the Woodlands when their churchyards were sold. (Library Company of Philadelphia.)

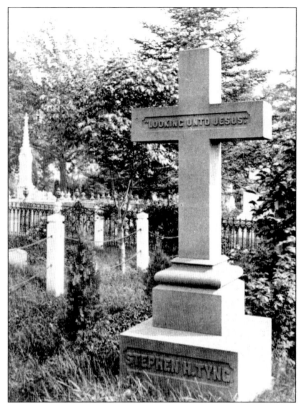

As at Laurel Hill, many Woodlands grave sites are a testament to the high mortality rate of children in the 19th century. This elaborate monument marks the grave of Edward Alexander Orme (1830–1841), eldest son of George Robert Orme and grandson of Edward Orme, Esquire, of Bayswater, Middlesex, and Fitzroy Square, London. The monument stands today, badly worn and stripped of its iron fence and coping. (Library Company of Philadelphia.)

Thomas W. Evans (1823–1897) was a highly skilled dentist who pioneered the use of nitrous oxide and won awards for his gold fillings. Setting up shop in Paris, "Handsome Tom" became dentist to Napoleon III, the Empress Eugenie, and the imperial *haut monde*. Evans acquired a fortune, not just from the jeweled stickpins and snuffboxes bestowed upon him by grateful patients, but by speculating in real estate using their inside information. (L.M. Arrigale.)

When the Franco-Prussian War led to the downfall of the empire, Evans spirited the distraught Empress Eugenie out of France by disguising her as a patient. His estate of $4 million paid for the tallest funereal monument in Philadelphia, with enough left over to create the Thomas W. Evans Museum and Dental Institute (today the Dental School of the University of Pennsylvania). (L.M. Arrigale.)

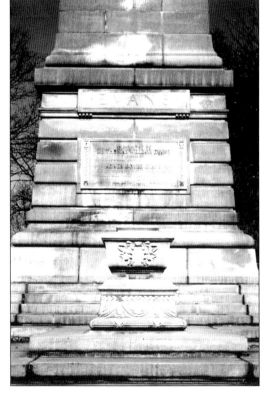

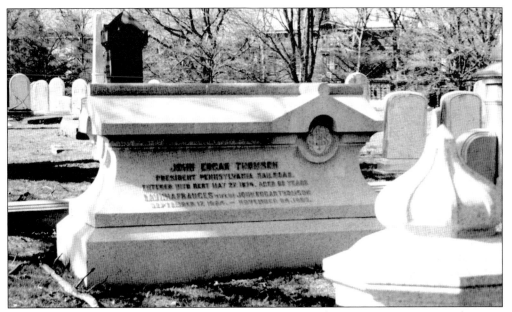

John Edgar Thomson (1808–1874) began his career as a rodman in a survey crew and rose to become third president of the Pennsylvania Railroad from 1852 until his death. Today, the John Edgar Thomson Foundation still offers scholarships and financial aid to the children of deceased railroad workers. Thomson's cruciform monument bears a slight resemblance to the steam engines that once traveled on his railroad. (L.M. Arrigale.)

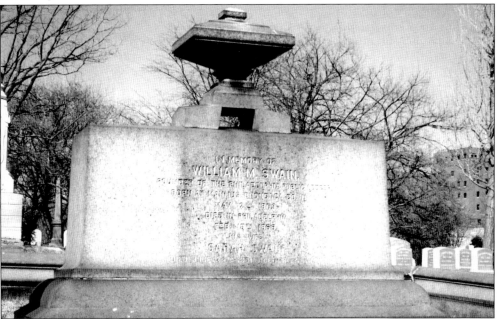

William M. Swain (1809–1868) cofounded the Philadelphia *Public Ledger*, the city's first "penny daily" for the common man, in 1836. The *Public Ledger* pioneered the use of the pony express and magnetic telegraph to transmit messages, and, starting in 1847, was printed on the first rotary press ever built. Following Swain's sale of the *Public Ledger* to George W. Childs in 1864, his son William J. Swain (1839–1903) founded the *Public Record* in 1870. (L.M. Arrigale.)

Samuel D. Gross (1805–1884) was considered the finest surgeon of his time, as well as a noted educator and author. Gross was also a founder of the American Medical Association and the American Surgical Association. His lasting fame, however, comes from being the subject of Thomas Eakins's masterpiece *The Gross Clinic*, painted in 1875 and now on display at Gross's alma mater, Jefferson Medical College. (L.M. Arrigale.)

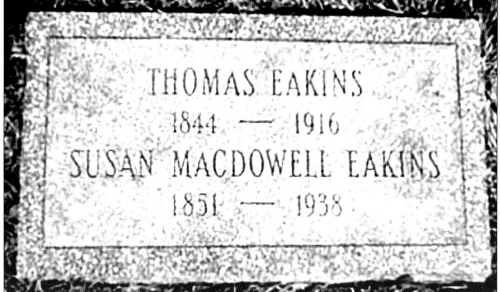

Thomas Eakins (1844–1916), subject of scorn and scandal during his lifetime, has been recognized as America's finest realist painter. After his wife, artist Susan MacDowell Eakins, died in 1938, their mixed ashes were interred in an unmarked grave in his father's lot at the Woodlands. The current marker was given by an anonymous donor in 1983 as part of the Adopt-A-Grave program started by the late historian Ruth Molloy. (John Schimpf, Lower Merion, Pennsylvania.)

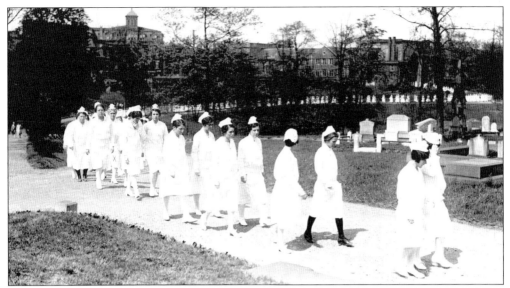

The Woodlands holds two central figures in American nursing: Alice Fisher (1839–1888) and Lillian Clayton (1876–1930). Fisher organized the nurses at "Old Blockley" (Philadelphia General Hospital) and established what is now the University of Pennsylvania School of Nursing. Clayton continued Fisher's work as chief nurse at the hospital, introduced numerous educational reforms, and became a leader in national organizations. The 1930 photograph above shows nurses from the school of nursing marching in Clayton's funeral procession, entering the Woodlands through the McArthur gate from Hamilton Walk on the University of Pennsylvania campus. Every year since Fisher's death until recently, nurses have held a processional to the Woodlands. Below, nurses at the 1992 ceremony leave carnations on the graves of Clayton (left) and Fisher (right). (Center for the Study of the History of Nursing, School of Nursing, University of Pennsylvania.)

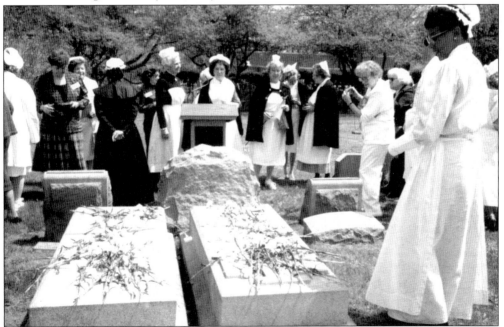

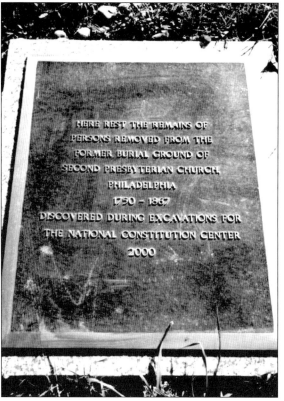

In the summer of 2000, archaeologists investigating the site of the National Constitution Center on Independence Mall unearthed the remains of members of the Second Presbyterian Church, whose burial ground once lay on the west side of Fifth Street between Arch and Cherry Streets. Although it was thought that all the bodies in this site had been removed to Mount Vernon Cemetery in 1867, 88 sets of human remains were unearthed over the summer. On December 20, 2000, the remains were reverently reinterred at the Woodlands, with a committal service for these members of the Second Presbyterian Church. The photograph above shows members of the original archaeological dig acting as pallbearers for the remains during their reburial. On the left is the bronze plaque that marks their new resting place. (Dr. John Paul Decker.)

Four
OTHER VICTORIAN CEMETERIES

Less than a year after Laurel Hill opened in 1836, a second rural cemetery was founded on Broad Street in what was then Penn Township, north of Philadelphia. Originally called Père-Lachaise after the first rural cemetery in Paris, it was quickly renamed Monument Cemetery. Despite a shaky financial start, Monument Cemetery soon rivaled Laurel Hill and survived until supplanted by a Temple University parking lot in 1956 (see page 118).

The success of Laurel Hill, Monument, and the Woodlands sparked a rural cemetery boom in Philadelphia. The 15 years from 1845 to 1860 saw the founding of Cedar Hill, Glenwood, Greenwood, Mount Moriah, Mount Peace, Mount Vernon, Odd Fellows, and United American Mechanics cemeteries. All independent companies, these cemeteries competed fiercely against each other, touting their superior locations and prospects. An 1871 guidebook for Mount Moriah boasted that the cemetery's "geographical position dispels all apprehension of its ever being disturbed by the dangers or annoyed by the nuisances [of the] tide of improvement which had already enveloped Monument Cemetery, and is now hemming in the Odd-Fellows, Glenwood, and the American Mechanics, and in a few years will reach Mount Peace, Mount Vernon, Laurel Hill and Old Oaks."

Acknowledging that Laurel Hill and the Woodlands had captured Philadelphia's elite, these later cemeteries targeted a more middle-class clientele. Each cemetery strove to outdo its competitors with an impressive gatehouse in the latest architectural style, be it Egyptian, Classical, Italianate, or a combination of all three. Each cemetery also promoted a star attraction, either a local celebrity or a magnificent monument like the Gardel tomb at Mount Vernon. No matter how distant the cemetery, it was sure to have a Center City sales office. Some, such as Greenwood, had sales representatives in each section of the city. Mount Vernon even advertised itself as "Mount Vernon at Laurel Hill," despite having no ties to the older, more established graveyard.

Many cemeteries sought alliances with the fraternal organizations popular in 19th-century America, such as the Masons, the Odd Fellows, or the Knights of Pythias, as a way of ensuring mass sales of lots. When an 1874 law allowed Philadelphia churches to sell their overcrowded churchyards, they were eagerly solicited by cemeteries anxious to provide new resting places for their past congregations. The Episcopal Church of St. James the Less, founded near Laurel Hill Cemetery in 1846, also offered a rural burial place for its congregants within an ecclesiastical setting.

By 1876, there were over 20 rural cemeteries in and around Philadelphia, catering to various social, economic, religious, ethnic, and racial groups. Despite the competition, most of them flourished. Philadelphia's population jumped 216 percent between 1850 and 1900, from 409,000 to 1.3 million inhabitants. As the city grew larger, denser, and more industrial, an ever greater number of Philadelphians sought a green, peaceful resting place for their loved ones. Today, all of the cemeteries in this chapter still exist, although a number of them are nearly or completely inactive.

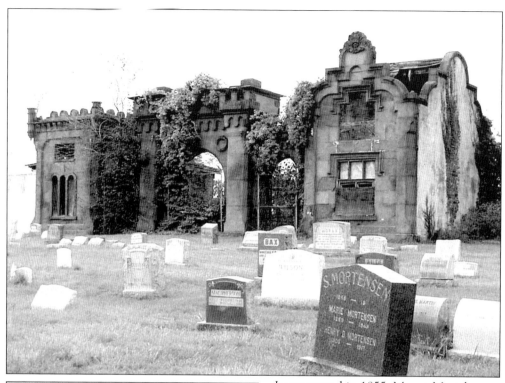

Incorporated in 1855, Mount Moriah Cemetery originally consisted of 54 acres on the western edge of Philadelphia. Its brownstone gateway and lodge on Islington Lane (today Kingsessing Avenue) was constructed in a "Norman castellated style." Initially, a circular tower stood on one side, and a white marble statue of Time loomed over the archway. Today, the gatehouse is crumbling (above). A few years after the opening of the cemetery, the statue of Time was removed from the gatehouse. It was purchased by John H. Jones, who placed it atop his own grave directly behind the gatehouse, where it stands today (left). By 1871, Mount Moriah had grown to 227 acres on both the Philadelphia and Delaware County sides of Cobbs Creek, which the managers called the "stream of Kedron." (Gloria Boyd.)

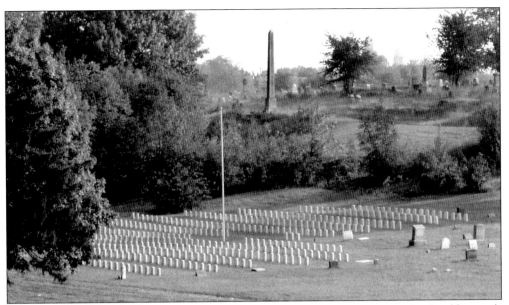

The Soldiers' Plot holds the remains of 405 Union soldiers, most of whom died at local hospitals during the Civil War. Although the plot originally held many Confederate soldiers as well, all but two of their bodies were removed to Philadelphia National Cemetery in Germantown in 1885 (see page 71). Today, the Department of Veteran Affairs (located at Beverly National Cemetery in Beverly, New Jersey) administers this plot and the naval plot at Mount Moriah. (Michael Brooks.)

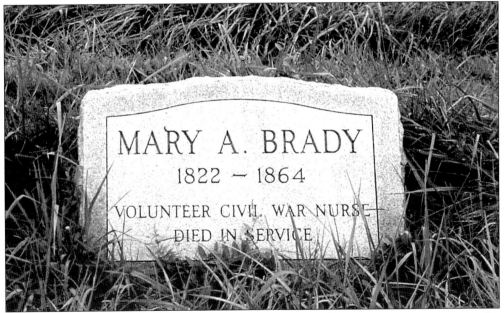

On a hill overlooking the Soldiers' Plot lies Mary Brady (1822–1864), an attorney's wife who cofounded the Ladies' Association for Soldiers' Relief. After traveling to army camps, Brady died of "disease of the heart, contracted by her voluntary efforts on behalf of the sick and wounded." The monument shown here was recently placed on her grave by the 28th Pennsylvania Historical Association and the Sons of Union Veterans. (Michael Brooks.)

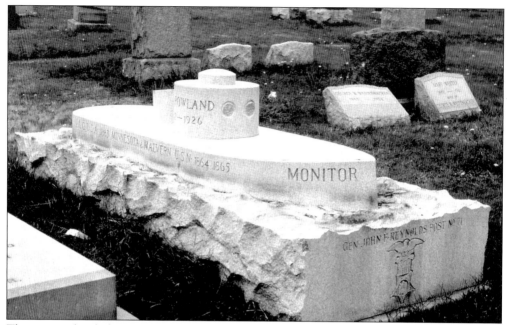

This granite battleship marks the grave of William Rowland (1847–1924), who served on the frigate USS *Minnesota* during the Civil War. It is carved in the form of the USS *Monitor* in honor of the ironclad Union warship that saved the immobilized *Minnesota* from the CSS *Virginia* (formerly the USS *Merrimack*) at the Battle of Hampton Roads on March 9, 1862, in the first battle between ironclad warships. (Michael Brooks.)

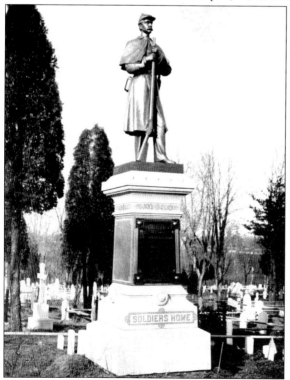

In 1884, a bronze statue of a soldier on a granite pedestal was transferred from the defunct Philadelphia Soldiers' Home to a new plot at Mount Moriah, where it marked the resting place of Civil War soldiers served by the home. About 30 years ago, the statue (seen here c. 1900) was stolen. Although since recovered, it remains in storage because its base was moved to Gettysburg in 1988 for a statue of Gen. John Gibbon. (Library Company of Philadelphia.)

Betsy Ross, legendary designer of the first American flag, died in 1836 and was buried in the Free Quaker Burying Ground at Fifth and Locust Streets with her third husband, John Claypoole. In 1856, the Claypooles were moved to Mount Moriah (seen above c. 1920). In 1975, the purported remains of Betsy and John Claypoole were transferred once again, to the backyard of the Betsy Ross House at 239 Arch Street.

Mount Moriah's vast size made it ideal for churches and fraternal organizations that required large plots. This monument is for the Keystone Chapter No. 175 of the Masons. Originally, a facsimile of the Ark of the Covenant rested beneath the triangular canopy. In addition to the Masons, numerous lodges of the Odd Fellows, Knights of Pythias, and American Mechanics also purchased lots in Mount Moriah. Today, the Friends of Mount Moriah Cemetery are working to restore monuments like this one. (Gloria Boyd.)

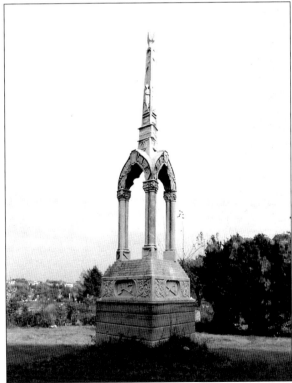

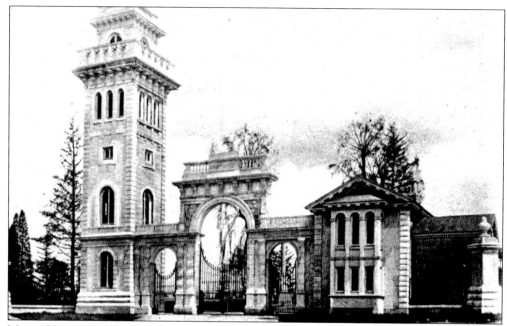

Mount Vernon Cemetery was founded in 1856 at Ridge and Lehigh Avenues, opposite Laurel Hill Cemetery. Shortly after its founding, the managers erected an Italianate gatehouse, which stands today minus the campanile. In 1867, over 2,500 bodies were removed from the Second Presbyterian Church's Arch Street churchyard to Mount Vernon, including those of Gen. William Knox, George Washington's secretary of state, and author and linguist Peter Stephen DuPonceau. (Robert M. Skaler.)

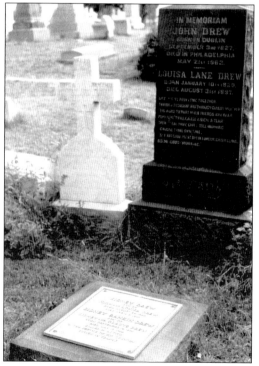

The Drew family lot at Mount Vernon contains a Philadelphia theatrical dynasty, including Louisa Lane Drew, grandmother to John, Lionel, and Ethel Barrymore. Although John wished to be buried in Philadelphia, he was entombed in the Calvary Cemetery mausoleum in Los Angeles. In 1980, John Barrymore Jr. had his father's body cremated and interred the ashes at Mount Vernon. Barrymore's grave was unmarked until recently, when his fans installed a simple gravestone. It bears the epitaph, "Alas, Poor Yorick," a reference to his acclaimed stage performance as Hamlet. (Michael Brooks.)

Mount Vernon's showpiece is the Gardel Monument. The pyramid was erected in 1864 to commemorate Mrs. Gardel, principal of a ladies' seminary, who died in Damascus on a world tour. Her memorial reflects her worldly interests, with statues of Europe, who inserts a funerary urn within the monument at the center; Asia, seated on a camel on the right; and Africa, seated on a Sphinx on the left.

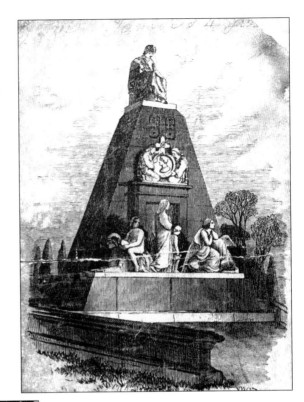

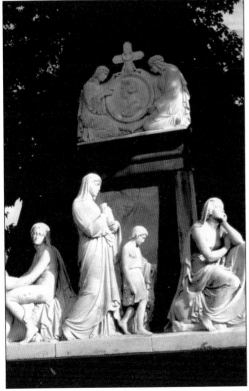

Over the central door, a bas-relief of Mrs. Gardel is supported by Hope and Faith. America sits atop the monument, surrounded by emblems of the physical sciences and the Bible, and extending a wreath to crown the head of the departed. For many years, the Gardel Monument was featured extensively on Mount Vernon brochures, such as the c. 1860 one above. Today, the monument stands guard over a derelict cemetery. (Left: Michael Brooks.)

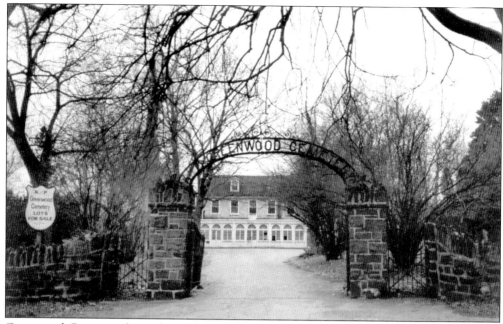

Greenwood Cemetery, located at Adams Avenue and Arrott Street in northeast Philadelphia, was founded in 1869 on the former country estate of Revolutionary-era physician Benjamin Rush. In March 1870, its charter was amended to change the name to the Knights of Pythias Greenwood Cemetery. Its president, Wilbur H. Myers, a leader in the Knights of Pythias, hoped to use funds from the sale of cemetery lots to members to build a new grand lodge. The cemetery never achieved the grandeur of its original design. A projected gatehouse and chapel, with bronze statues of Charity and chivalric knights, was replaced by a simple iron archway and stone wall (above, with the Colonial Rush House in the background). By 1871, a receiving vault with the emblem of the Knights of Pythias on its right side had been constructed (below). (Gloria Boyd.)

Many Civil War soldiers rest at Greenwood, including Robert E. Solly, son of the 19th-century owners of the property, who died near Martinsburg, Virginia, on September 20, 1864, while serving with the Pennsylvania Volunteers Cavalry. Today, the once-upright tombstone lies flat on the ground. Historians, neighborhood activists, and Solly descendants are working together to ensure the preservation of the property's monuments and buildings. (Gloria Boyd.)

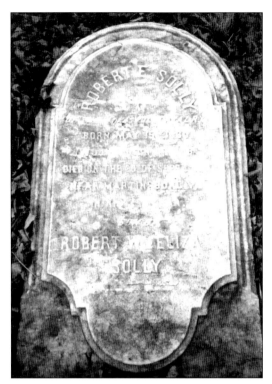

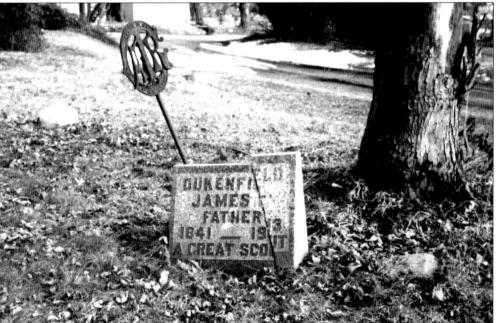

When *Vanity Fair* asked W.C. Fields to write an imaginary epitaph in 1924, his response was, "On the whole, I would rather be living in Philadelphia." This is probably not what he had in mind. The comedian was born William Claude Dukenfield in Philadelphia on January 29, 1880. His parents, James and Kate Dukenfield, were buried in Greenwood. James's gravestone is cracked, while Kate's stone disappeared years ago. (Gloria Boyd.)

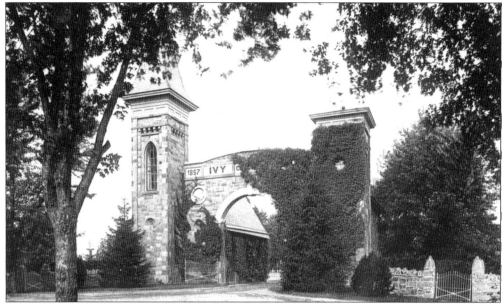

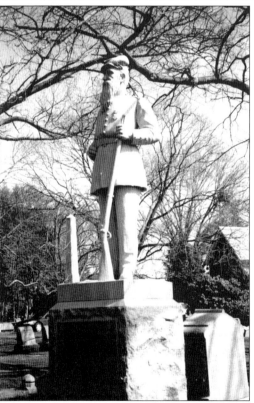

The gatehouse and chapel of Ivy Hill Cemetery still stand on Easton Road in Mount Airy, as they have since 1867 (above). Originally chartered as the Germantown and Chestnut Hill Cemetery Company, the name was changed to Ivy Hill in 1871. One of its most notable monuments is that of Civil War veteran Melville H. Freas (left). A member of the 150th Pennsylvania Volunteers Cavalry (Bucktail Regiment), Freas was taken prisoner at the Battle of Gettysburg and held at Belle Island, Virginia. In 1914, the 73-year-old Freas commissioned a life-sized statue of himself in his Bucktail Regiment uniform at a cost of $5,000, a significant amount given his salary as a mailman. Every Memorial Day, Freas and his grandchildren would march from Haines Street in Germantown to the cemetery, where he would fire a one-gun salute over his monument. (Left: L.M. Arrigale.)

As the first rural cemetery in northwest Philadelphia, Ivy Hill proved popular with residents of Germantown, Mount Airy, and Chestnut Hill. Among them were the Rev. Frederick Jelden (1848–1900), seen on the right with his wife Marie, son George, and daughter Edith. Jelden, pastor of the St. Thomas Lutheran Church on Morton Street in Germantown, died of pneumonia at the age of 55 in March 1900. The photograph below shows his burial site at Ivy Hill, with its copings and floral tributes but with no monument yet in place. Normally, stone copings were the first fixture placed at a lot, to mark the space with the family name. The lack of a tombstone indicates the unexpected death of Jelden at a relatively young age. (Germantown Historical Society.)

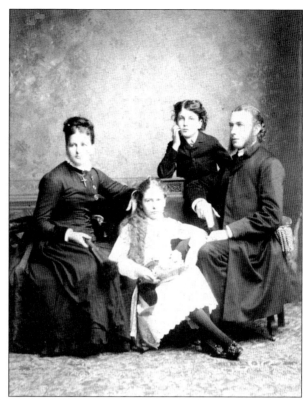

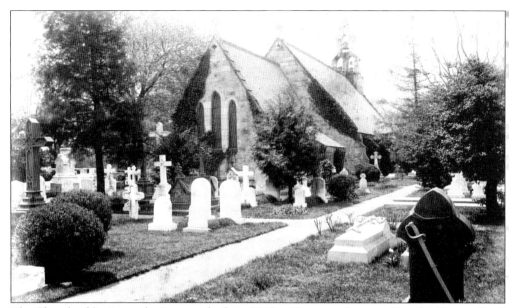

The Church of St. James the Less was built in 1846 at Nicetown Lane and Lamb's Tavern Road (today Hunting Park Avenue and Clearfield Street) in East Falls, on land acquired from Laurel Hill Cemetery. Its founder, merchant Robert Ralston, imported plans from England to build an authentically Gothic church. Its churchyard (shown above c. 1890) is filled with Newbolds, Powells, Tilghmans, and other notable Philadelphia families. The gravestone with the bronze saber in the right foreground is that of Mark Wilkes Collet, M.D., Civil War colonel and commander of the 1st New Jersey Volunteer Infantry regiment, killed in the attack on Salem Church on May 3, 1863. Shown below is the family lot of the Dobsons, textile mill owners who dominated East Falls society from the Civil War until the Depression. (Church of St. James the Less.)

The Wanamaker Memorial Tower was built in 1909 at the southwest entrance of St. James the Less. The 50-foot granite tower houses a carillon of fifteen bells, two small chapels, and the Wanamaker family mausoleum. The photograph on the right shows the bells being installed in the tower c. 1915. (Church of St. James the Less.)

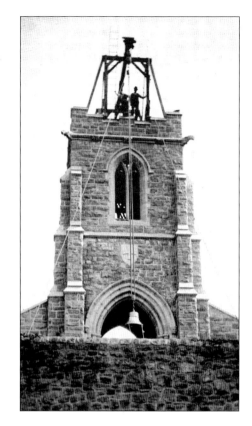

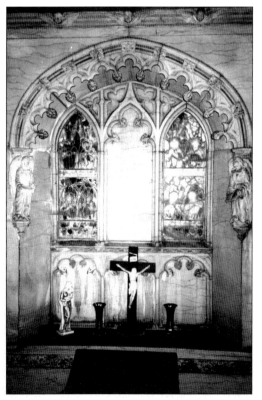

On the left is a detail of the north chapel, which holds the remains of John Wanamaker (1838–1922), founder of the largest department store in America; his wife Mary (1839–1920); his eldest son Thomas (1868–1908), in whose memory the tower was built; and his youngest son Lewis Rodman (1863–1928), who commissioned the tower. Other members of the family rest in the chapels and in an underground vault. The vault's massive lid is raised by an iron chain lowered through the center of the tower. (Church of St. James the Less.)

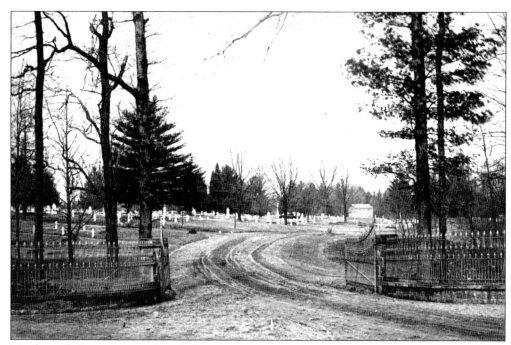

Northwood Cemetery was founded in 1878 at City Line (Cheltenham) Avenue and Haines Street to serve the growing population of the East Germantown and Oak Lane neighborhoods. Shown above is the main entrance at Fifteenth and Haines Streets c. 1900. Below is a typical family plot in its circle section, with chairs for visitors. Northwood set aside a section for British nationals "who served their King and Country and now rest here." It was in this section that the remains of a Revolutionary War British soldier were buried in November 1986. Believed to have been killed at the Battle of Germantown in October 1777, the soldier's remains were unearthed in 1985 by a construction crew in Mount Airy. A button found with the bones bore the numeral "52," identifying the soldier as a member of the 52nd Light Infantry Battalion.

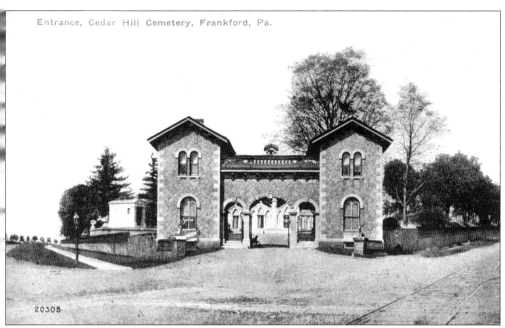

Cedar Hill was founded in 1849 at Frankford and Cheltenham Avenues in what was then the Frankford borough of Philadelphia County. The Cedar Hill gatehouse dates from 1869. As the population of the area grew, Cedar Hill became so popular that a second cemetery, North Cedar Hill, was founded across from it in 1860. (Robert M. Skaler.)

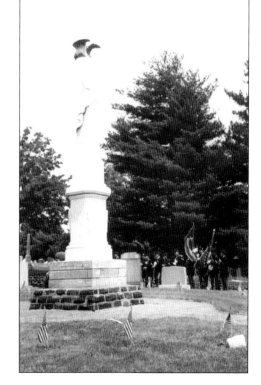

On the highest point in Cedar Hill stands the Soldiers' Monument, dedicated on July 4, 1867. A bald eagle with spread wings guards the American flag draped over the top of the marble shaft. Numerous Civil War soldiers are buried in Cedar Hill, including Congressional Medal of Honor winner Alexander Crawford (1842–1886) of the USS *Wyalusing*, who attempted to blow up the Confederate ram *Albemarle* in 1864. (Andy Waskie, Ph.D.)

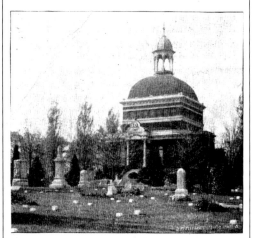

Chelten Hills Cemetery, established in 1879 in East Germantown, was one of the first Philadelphia cemeteries to offer its customers a crematorium. When this advertisement was circulated c. 1910, about 50 crematoria existed in the United States, and fewer than 6,500 Americans were cremated each year. In 1999, nearly 20 percent of all Pennsylvanians who died were cremated. Over the next decade, that percentage is expected to rise to 43 percent.

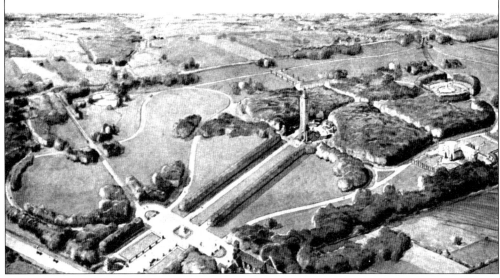

By 1930, Philadelphia was losing both its living and dead populations to the suburbs. Whitemarsh Memorial Park near Ambler was an example of the suburban burial estates that gained favor as the city's rural cemeteries grew overcrowded and urbanized. Laid out by architect Paul Philipe Cret (who also designed the Benjamin Franklin Parkway), Whitemarsh Memorial Park eschewed individual monuments for in-ground plaques, open landscapes, and elaborate public buildings.

Five
NEIGHBORHOOD GRAVEYARDS

Before 1854, the city of Philadelphia consisted of the land between the Delaware and Schuylkill Rivers, bordered by South and Vine Streets. The rest of Philadelphia County was a patchwork of nine districts, six boroughs, and thirteen townships. Communities ranged from built-up areas, like Northern Liberties and Southwark (respectively the sixth and seventh largest cities in the United States in 1800), to tiny villages, like Smearsburg and Nittabaconck. Many of these neighborhoods are nearly as old as Philadelphia. Germantown was founded in 1683, and Frankford dates back to at least 1687.

Given the difficulty of early travel, it is not surprising that each community established its own burial grounds, usually connected to its church or churches. The Pennypack Baptist Burial Ground, attached to the first Baptist congregation in this country, has graves dating back to 1688. Byberry Friends Meeting, founded in 1683, had established a burial ground by 1692. By 1693, only a decade after its founding, Germantown had three burial grounds, two of which were open to all members of the community—at least initially. In 1755, Germantown opened its own Potter's Field "for all strangers, Negroes, and Mulattoes as die in any part of Germantown forever."

Each neighborhood's burial grounds reflect its own contribution to the history of Philadelphia and the United States. Germantown's churchyards are filled with the names of the early German immigrants who sought peace and religious freedom, such as Pastorius, Tyson, and Rittenhouse. They also hold casualties of the Battle of Germantown on October 4, 1777, a critical turning point in the Revolutionary War. Philadelphia National Cemetery in East Germantown—at one time the largest veterans' cemetery north of Arlington—holds the bodies of soldiers who fought in every American conflict from the War of 1812 to Vietnam.

In North Philadelphia, the remains of Lucretia Mott, Robert Purvis, and other leaders in the 19th-century struggles for equal rights for women and African Americans rest at the Fair Hill Burial Ground at Germantown Avenue and Cambria Street. Fishtown's Palmer Cemetery holds members of the Cramp family, creators of a shipbuilding dynasty that helped establish Philadelphia's mercantile supremacy.

In 1854, the various townships, boroughs, and districts of Philadelphia County were consolidated into the city of Philadelphia. Improved travel and the growth of rural cemeteries throughout the city spelled the end of the neighborhood graveyard. Some, like Chestnut Hill's Union Burying Ground, were replaced by residential development. Others still exist but are inactive, such as Roxborough's Leverington Cemetery and the Upper and Lower Burying Grounds in Germantown.

Only a few remain active, such as Palmer Cemetery in Fishtown. Palmer still provides free burial space to residents of the area bounded by the Delaware River, Frankford Avenue, and York Street. According to historian Ken Milano, founder of the Kensington History Project, "the method of deciding where to bury is simple. The family chooses a spot, a pole is used to poke the ground to see if there are any obstructions. If there are no obstructions they can bury; otherwise you keep poking."

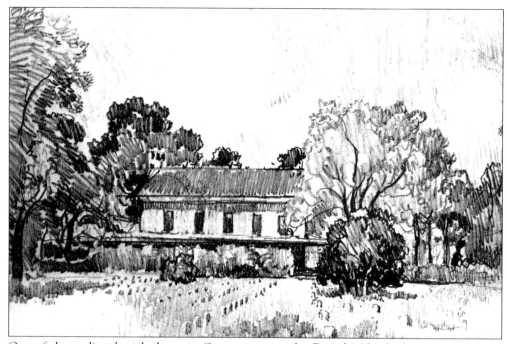

One of the earliest burial places in Germantown is the Friends' (Quaker) Meeting Burying Ground, founded c. 1690, when the first log meeting house was built at Coulter Street and Germantown Avenue. For many years, grave markers were either forbidden or strongly discouraged by the Friends' yearly meeting. When marked, most Quaker graves have small, low stones with the name or initials and birth and death years of the deceased. Shown above are the rows of markers in front of the Germantown Friends' Meeting House, as seen by Philadelphia artist Joseph Pennell c. 1910. Shown below is the Friends' burial certificate for Joseph Howell, who died August 18, 1889. A later hand has added the cryptic message, "Rejected to cast aside as useless/Refused to deni [sic] Something Solicited" to the certificate. (Germantown Historical Society.)

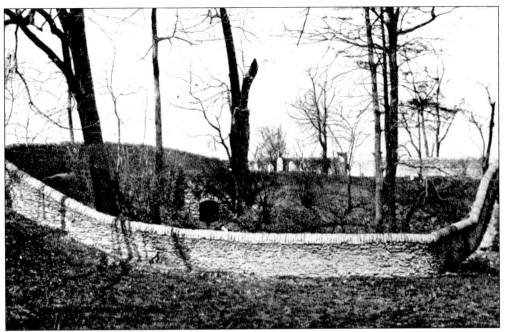

Shown above is the Logan family burying ground at Stenton, the historic Colonial mansion of James Logan at Eighteenth Street and Windrim Avenue. The burial vault shown in this early-20th-century photograph was never occupied. In the 1950s, the city of Philadelphia covered the plot with concrete to form part of Stenton Park. A few of the Logan gravestones were salvaged and are in the basement of the nearby mansion.

The de Benneville Burial Ground at Old York Road and Green Lane holds two British officers killed during the Battle of Germantown, Gen. James Agnew and Lt. Col. John Bird. Originally buried in Germantown's Lower Burying Ground, their bodies were dug up before the British evacuated Philadelphia in 1778 to prevent desecration. Dr. George de Benneville, who cared for the wounded on both sides, allowed their reburial in his family lot.

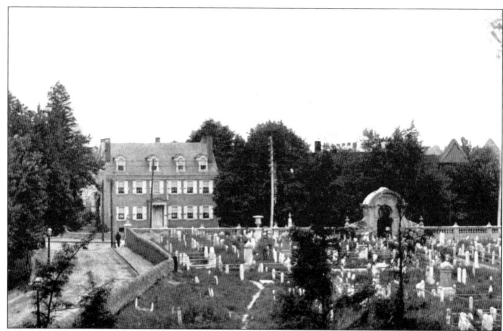

Germantown's first public cemetery, the Lower Burying Ground, was established c. 1690 on Germantown Avenue above Logan Street. Seen above c. 1905, it holds the oldest known gravestone in Germantown, that of nine-week-old Samuel Coulson, who died October 28, 1707. In 1850, merchant William Hood left a provision in his will to erect a marble front wall and an elaborate arched gate at the ground. In his honor, the site was renamed Hood's Cemetery. On East Logan Street, two fragments of an ancient tombstone have been set within the stone wall, showing a skull and crossbones and the admonition "Memendo Mory," meaning, "Remember that you must die." The record book of the cemetery, dating back to 1735 and lost for more than 50 years, was recently recovered and given to the Germantown Historical Society, which administers the cemetery today. (Germantown Historical Society.)

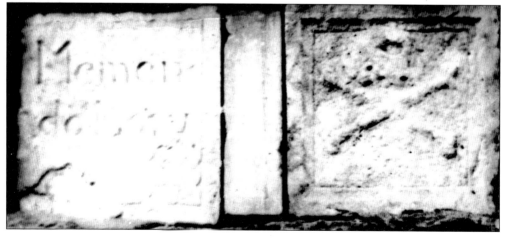

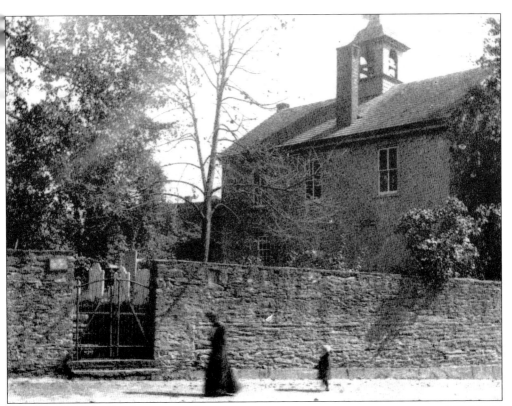

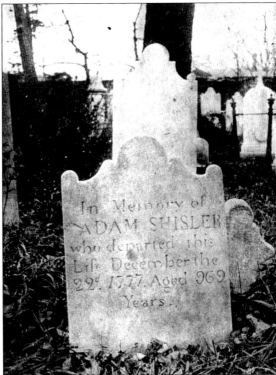

In 1692, a parcel of land was set aside on Germantown Avenue above Washington Lane for the inhabitants of upper Germantown. Known as the Upper, or Axe's, Burying Ground (after longtime superintendent John Axe), the ground holds the bodies of nine American soldiers killed at the Battle of Germantown, including Lt. Col. Henry Irwin, Capt. Jacob Turner, and 1st Lt. Thomas Lucas. In 1775, part of the ground was ceded to build the Concord School, shown above c. 1890. One of the most unusual tombstones shows that Adam Shisler died in 1777, aged 969 years (left). According to legend, the stone carver believed that Shisler was 96 years old. When he learned that Shisler was only 69, he carved a second "9" after the "6" and covered over the first "9" with plaster, which later fell off. (Germantown Historical Society.)

The Mennonite cemetery at 6121 Germantown Avenue (shown above c. 1865) predates the first Mennonite church, a log house built c. 1708. The current stone structure dates from 1770. In 1777, the fiercest fighting of the Battle of Germantown took place in and around the churchyard. Many soldiers were buried there and in the yard of the Samuel Keyser house, which was later demolished, next door. (Germantown Historical Society.)

St. Michael's, the first German Lutheran church in America, was founded at 6700 Germantown Avenue before 1730. Among those in its churchyard are Christopher Ludwig, "director of baking" to George Washington's army; and Maj. James Witherspoon, who was killed at the Battle of Germantown and the son of the Rev. John Witherspoon of New Jersey. This photograph shows the third church in 1898, shortly before it was replaced by the present structure. (Germantown Historical Society.)

Philadelphia National Cemetery, at Haines Street and Limekiln Pike in the Pittville section of Germantown, was established in 1885 by the federal government for Civil War soldiers. Over 400 bodies were removed from various locations around Philadelphia and reinterred there, including 184 Confederate soldiers and sailors who died while prisoners. In 1911, the government unveiled the first monument ever erected to the Confederate dead in the north to mark their graves (right). Five years later, Maj. Gen. Galusha Pennypacker (1844–1916), the youngest Civil War general, was laid to rest in the cemetery. In 1945, a *Bulletin* photographer captured German prisoners of war tending the graves of American soldiers (below). Today, Philadelphia National Cemetery holds nearly 13,000 veterans and their family members, ranging from the War of 1812 to the Vietnam War. (Right: L.M. Arrigale; below: Urban Archives, Temple University.)

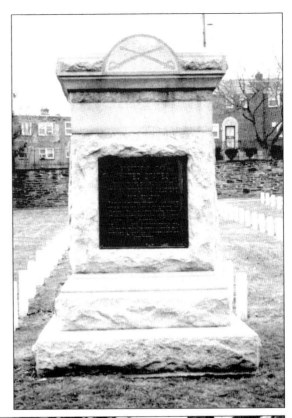

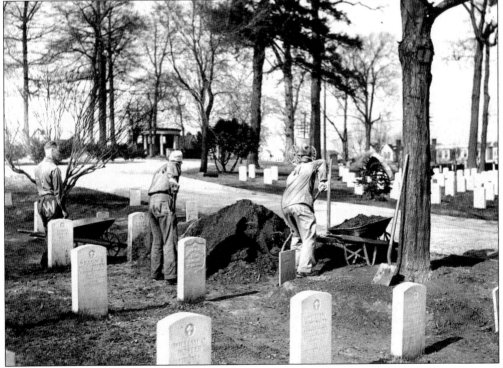

In rural Chestnut Hill, the primary burial site was the Union Burying Ground (shown above c. 1915), opened in 1828 on West Gravers Lane between Crefeld and Navajo Street. By 1917, the derelict cemetery had been dubbed "No Man's Land" and was the scene of secret midnight burials. George Woodward purchased the property and had the remaining bodies moved to Arlington Cemetery in Upper Darby. Today, attractive stone houses cover the site. Two Chestnut Hill churches, the Baptist and the Methodist, had their own churchyards. Shown below is the Chestnut Hill Methodist church and churchyard in the 1860s. In 1884, a new church was built and the gravestones (but not all of the bodies) in front of the church were moved behind it. (Above: Germantown Historical Society; below: Chestnut Hill United Methodist Church.)

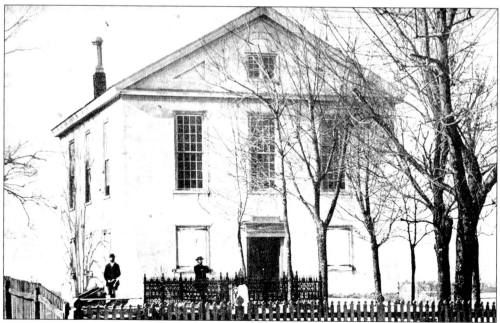

Originally the Levering family burial plot, Leverington Cemetery on Ridge Avenue in Roxborough was incorporated in 1857 by descendants of the original owners. Its two largest monuments honor America's Revolutionary and Civil War dead. Erected in 1860, the Virginia Trooper monument (right) commemorates 18 soldiers from a detachment of Light Horse Harry Lee's Virginia Legion who were killed by British soldiers at a barn on the nearby Woods farm in the winter of 1777–1778. (L.M. Arrigale.)

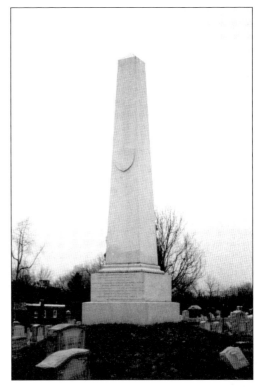

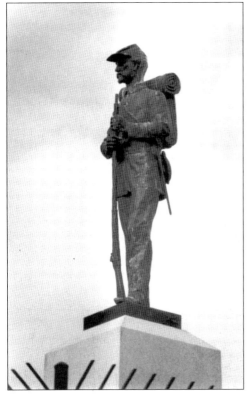

The Civil War monument was originally erected in 1872 to honor local soldiers and was dedicated by Gen. George Gordon Meade. In 1913, a new granite base was erected for the statue. Repeatedly vandalized throughout its history, the monument is now protected by the steel bars. (Michael Brooks.)

The Fair Hill Burial Ground was founded in 1703, adjacent to the Fair Hill Friends Meeting House at Germantown Avenue and Cambria Street (above). The burial space was laid out in 1843 and enlarged in 1853 to its present size of nearly five acres. Among those buried here is Lucretia Mott, a leader in the early abolitionist and women's rights movements; her husband and fellow abolitionist James Mott; Edward Parrish, founder of Swarthmore College; and African American leaders Robert and Harriet Forten Purvis. After years of neglect and vandalism, the cemetery has been restored under the auspices of the Fair Hill Burial Ground Corporation. In the photograph on the left, the corporation's treasurer Linnell McCurry and her son Peter rest atop the burial ground's receiving vault during one of the corporation's periodic clean-up days. On April 12, 2003, the revived Fair Hill Burial Ground celebrated its 300th anniversary. (Fair Hill Burial Ground Corporation.)

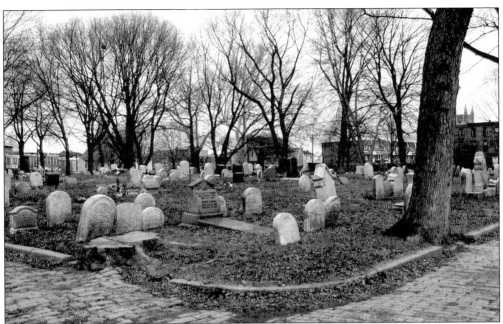

Palmer Cemetery (also known as the Kensington Burial Ground) in Fishtown is one of the oldest free neighborhood burial grounds in the nation. Established as a family burial ground by Kensington founder Capt. Anthony Palmer, the seven-acre site was deeded as a cemetery by his descendants for all those living within the boundaries of Kensington in 1765. To this day, anyone living within the triangle formed by the Delaware River, Frankford Avenue, and York Street at the time of their death may have a free lot in Palmer, providing that they find a plot where a pole stuck in the ground hits no obstructions. Among those buried in Palmer Cemetery are Revolutionary War hero and calico printer John Hewson, lumber merchant Alexander Adair, and members of the Cramp shipbuilding family. (Eugene Stackhouse.)

Trinity Church, at Oxford and Rising Sun Avenues in northeast Philadelphia, dates back to 1698, when its Anglican members shared a log meetinghouse with the Oxford Society of Friends. Its churchyard (seen c. 1900) is filled with families whose names are now streets in northeast Philadelphia, such as Cottman, Kerper, Overington, and Unruh. Among the former ministers who rest there are Aeneas Ross, minister from 1742 to 1758, brother of Declaration of Independence signer George Ross, and father-in-law of flag maker Betsy Ross; and Edward Buchanan, brother of Pres. James Buchanan and rector of Trinity from 1854 to 1882. Buchanan lies next to his wife, Anne Eliza Foster, sister of songwriter Stephen Foster. (Robert M. Skaler.)

Trinity boasts many unusual Colonial gravestones, including that of Mary Souter (seen c. 1910), with four small cherub heads floating amidst her epitaph.

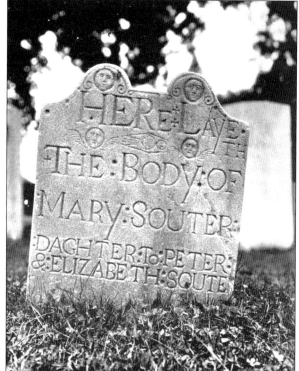

The Pennypack (Pennepek) Baptist Church was organized in 1688 in what was then Lower Dublin Township and is now the Bustleton area of northeast Philadelphia. The current churchyard dates from between that time and 1707, when the first church was erected. This 1702 gravestone (shown c. 1910), with its skull, crossbones, and hourglass, is similar in style to those found in Colonial New England burial grounds.

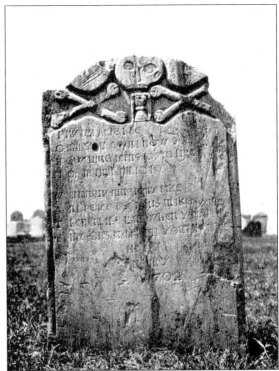

The Frankford Presbyterian Church was founded in 1770 at Frankford Avenue and Church Street, although the current building dates from 1860. Like Trinity Church, the Frankford Presbyterian churchyard contains families whose names are now local streets, such as Castor and Foulkrod. Pictured above are the obelisks marking the graves of Palmyra Carpentier (1803–1884) and Francis Carpentier (1811–1856).

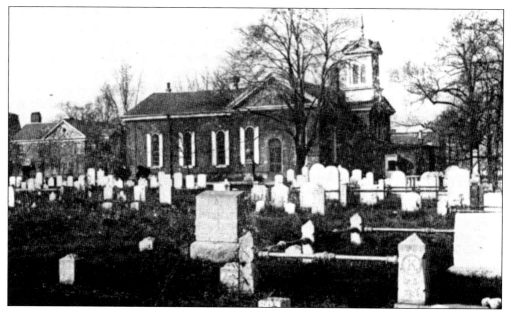

St. James Kingsessing (seen c. 1890), at Sixty-eighth Street and Woodland Avenue in the southwest corner of Philadelphia, was founded in 1760. Originally a Swedish Lutheran branch of Old Swedes' Church, it became an Episcopal church in 1844. Among those who worshiped here and are buried here are members of the Broomall family, whose descendants would give their name to the Delaware County town.

The Trinity Lutheran cemetery at Eighteenth and Wolf Streets in South Philadelphia served the predominantly German-American congregation of Trinity Lutheran Church, founded in 1844. This 1910 photograph shows the family plot for Jonathan Prichard (1828–1915), who was actually never buried there. The only family member buried at Trinity Lutheran, Anna L. Prichard (1882–1895), was later moved to a family mausoleum in Mount Moriah Cemetery. (H.C. Wood Memorials, Harvard Wood III.)

Six

AFRICAN AMERICAN BURIAL SITES

While many early graveyards were destroyed by Philadelphia's growth, African American burial sites were particularly prone to obliteration. This was a reflection of the vulnerability of the city's African Americans during much of their history, as they struggled to build and maintain their community in the face of economic, social, and racial oppression. Today, the forgotten history of these cemeteries is being uncovered, sometimes literally, as part of the reconstruction of African American history.

As slaves, African Americans were as subject to their masters' whims in death as they were in life. Burial options were usually limited to a lot on their masters' property, or the Negroes' section of the Strangers' Burial Ground (Washington Square) near Seventh and Walnut Streets. Funerals were often held at night, the only time when slaves were free from their labors, and when they would not be subject to harassment by whites.

A few churches, such as the Second Presbyterian Church, offered separate burial plots for their black worshippers, segregating them from the white congregation. Many places of worship barred African Americans from their burial grounds completely. Lucy, black slave to the Jewish Marks family in Colonial Philadelphia, worshiped at Mikveh Israel and wished to be buried in its Spruce Street Cemetery. After the congregation refused her dying request, the Marks family sneaked her body into the cemetery late at night and buried her near the gate. Similarly, the founding of Germantown's Potter's Field in 1755 was partly prompted by a black family's attempt to bury their dead child in the Upper Burying Ground.

After the American Revolution, Philadelphia's black leaders began to develop institutions to serve the largest African American community in America. In 1782, six free blacks petitioned, unsuccessfully, to have the Negroes' Burying Ground in Washington Square demarcated by a fence. The Free African Society, founded by Richard Allen and Absalom Jones in 1790, acted as a burial society in addition to aiding the poor and sick. By this time, black churches—led by Allen's Bethel African Methodist Episcopal Church and Jones' African Episcopal Church of St. Thomas—offered other burial options.

Founded in 1849, Lebanon Cemetery in South Philadelphia and Olive Cemetery in West Philadelphia were nonsectarian cemeteries for African Americans, who were excluded from most of the new rural cemeteries. Although plagued by scandal and managerial disputes, both cemeteries served African Americans until they were condemned by the city. In the 19th century, cemetery ownership served as a route to financial success for such black business leaders as Stephen Smith and Jacob White. Many blacks also prospered in the undertaking business during this time, including Robert Bogle, Peter Albert Dutrieulle, and Henrietta Bowers-Duterte, the state's first female undertaker.

The 20th century saw the development of suburban African American cemeteries, such as Eden in Collingdale, Merion in Lower Merion, and Mount Lawn in Sharon Hill. Although integration has opened the doors to many formerly all-white enclaves, these cemeteries continue to play a major role in Philadelphia's African American community.

Many African American slaves and servants were buried on the land of the families they served. In the southeast corner of historic Bartram's Garden, overlooking the Schuylkill River, lies the grave of Harvey, shown here c. 1900. Born a slave, Harvey was freed by John Bartram and acted as steward of the noted botanist's farm. The grave marker shown here was removed in the early 20th century. (John Bartram Association Collections.)

In the 1700s, the Strangers' Burial Ground (Washington Square) was one of the few places in Philadelphia where African Americans could be buried. Known as "Congo Square," it was a favorite gathering place for slaves and freemen, who would leave food and drink on the graves of loved ones. In 1782, black leaders sought to erect a fence around "the Negroes Burying ground," probably in the square's northwest corner. (L.M. Arrigale.)

Richard Allen (1760–1831), a former slave, founded the African Methodist Episcopal Church in 1791 and served as its first bishop from 1816 until his death. In 1794, the Bethel A.M.E. Church opened on Sixth Street near Lombard. Allen and his wife, Sarah, are entombed in the current "Mother Bethel" church, built in 1889. Mother Bethel had a nearby burial ground in Queen Village that became a park in the late 1800s. (Gary Reed, Mother Bethel A.M.E. Church.)

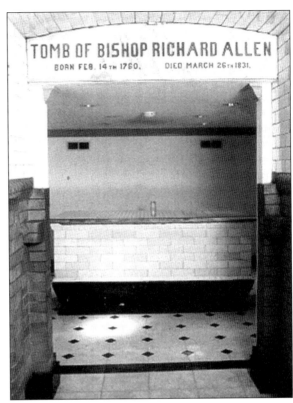

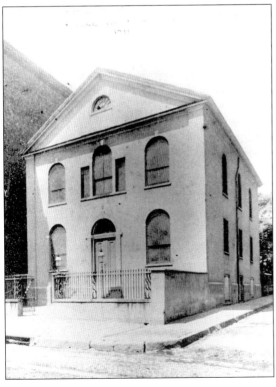

Absalom Jones (1746–1818) founded the African Episcopal Church of St. Thomas in 1792. The first church (shown c. 1880) opened in 1794 at Fifth and Adelphi Streets, with its churchyard behind the building. After the church was demolished in 1887, Jones and the other residents of its churchyard were moved first to Lebanon Cemetery, then to Eden Cemetery. In 1991, Jones's remains were exhumed, cremated, and placed in a reliquary in the Absalom Jones altar of the current church at 6361 Lancaster Avenue. (Archives of the African Episcopal Church of St. Thomas.)

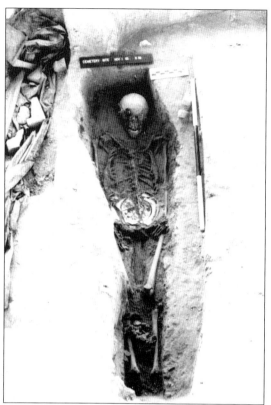

In 1980, archaeologists monitoring construction of the Commuter Rail Tunnel in Center City unearthed one of two burial sites of the First African Baptist Church, located at Eighth and Vine Streets from 1823 until 1842. The site provided a glimpse into an early-19th-century African American community whose lives were marked by hard labor, poor nutrition, and early mortality. Some graves showed signs of African burial customs, such as a woman buried with a ceramic plate placed on her stomach (left). The burial map (below) shows how tightly the 140 recovered remains were packed into the small space, with some graves holding five bodies. After scientific examination ended, the remains were reinterred in Eden Cemetery in 1987. In 1995, they were joined by 89 inhabitants of the other FABC burial site at Tenth and Vine Streets. (John Milner Associates.)

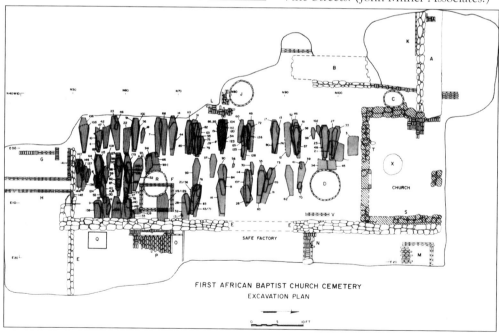

Founded in 1807, the Campbell A.M.E. Church is currently located on Kinsey Street in the Frankford section of Philadelphia. Among those buried in its churchyard are Wilson Barrett, who died in 1903 at the age of 63. According to his tombstone, Barrett served in Company B of the 5th Regiment Massachusetts Volunteer Cavalry, the only African American cavalry unit from that state to serve in the Civil War.

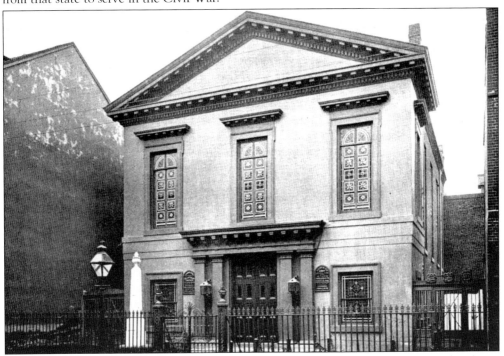

The Lombard Street Central Church was organized by members of the Second African Presbyterian Church in 1844. The first church building, shown here c. 1890, was erected in 1846 on Lombard Street between Eighth and Ninth Streets. After the church's first pastor, the Rev. Stephen H. Gloucester, died in 1850, his remains were placed in a vault in front of the church and marked with the obelisk seen above. (Germantown Historical Society.)

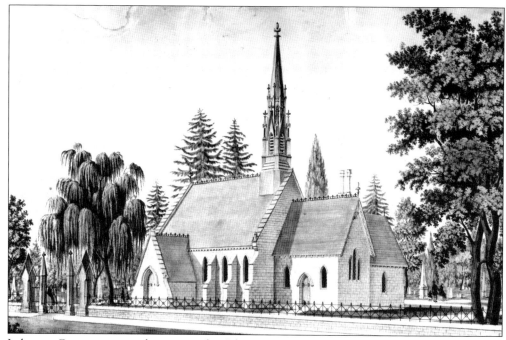

Lebanon Cemetery, a rural cemetery for African Americans, was founded in January 1849 on the Passyunk Road near today's Eighteenth and Wolf Streets in South Philadelphia. This print shows its chapel as it appeared in the 1850s. The 11-acre cemetery soon grew overcrowded and was tarnished by a body-snatching scandal in 1887. Condemned by the city in 1899, Lebanon closed in 1903, and its bodies were moved to Eden Cemetery. (Historical Society of Pennsylvania.)

Octavius Valentine Catto, one of Philadelphia's black leaders after the Civil War, was a teacher at the Institute for Colored Youth (today Cheyney University), a major in the Pennsylvania National Guard, and a political organizer who led a campaign to desegregate streetcars. In November 1871, he was murdered by a white thug during an election riot. Catto's funeral procession to Lebanon Cemetery was the largest in Philadelphia since Abraham Lincoln's in 1865. Today, he lies in Eden Cemetery. (Andy Waskie, Ph.D.)

Olive Cemetery, Philadelphia's second rural cemetery for African Americans, was founded in February 1849 at Forty-sixth Street and Girard Avenue in West Philadelphia. At one time, it was owned by Stephen Smith (1796–1873), a former slave who became one of the wealthiest black men in America. Smith also established the Zion Mission and founded the Home for Aged and Infirm Colored Persons (today the Stephen Smith Home). The eight-acre cemetery closed c. 1920, and its remains were moved to Eden and Mount Zion Cemeteries in 1923. These photographs show its abandoned chapel (above) and front gates (below) in 1925, shortly before they were demolished for the construction of the Blankenberg Elementary School. Recently, Olive Cemetery served as the location of a critical scene in the 1995 novel by Lorene Cary, *The Price of A Child*. (Library Company of Philadelphia.)

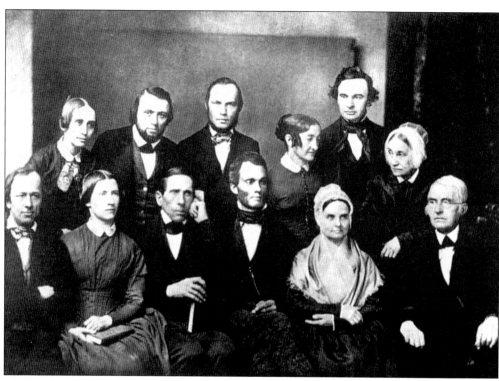

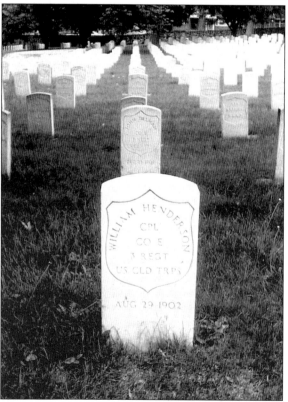

A few cemeteries rebelled against the strict segregation that was standard in 19th-century Philadelphia. Fair Hill Burial Ground (see page 74) holds the remains of Robert Purvis (1812–1898) and his wife, Harriet Forten Purvis (1810–1875), leaders in the Underground Railroad. The c. 1860 photograph above shows a bearded Purvis in the front row, next to Lucretia Mott, his fellow abolitionist, who is also buried at Fair Hill. Philadelphia National Cemetery in Germantown included African American soldiers from its inception in 1885, although they were buried separately, in George Washington Section 926, today part of Section G (left). A 1927 newspaper article noted that "those who know the forlorn characteristics of the average negro burial ground are quick to note that here in the National Cemetery the plot of the negroes is just as attractive as the rest of the grounds."

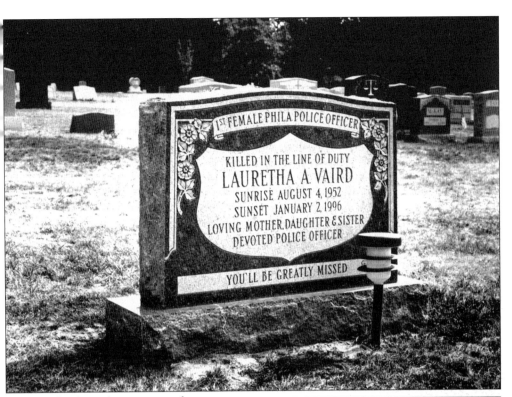

In 1876, the funeral procession of African American caterer Henry Jones was turned away from Mount Moriah Cemetery, even though he was a fully paid lot owner there. His survivors brought suit against the cemetery, and the Supreme Court confirmed Jones's right to be buried in Mount Moriah. During the 20th century, many cemeteries in Philadelphia gradually opened their doors to African Americans. Among them was Ivy Hill Cemetery in Mount Airy. Today, Ivy Hill is the resting place of Lauretha Vaird (1952–1996), the first female Philadelphia police officer to be killed in the line of duty (above); and Rev. Donald George Kenneth Ming (1930–2002), 97th bishop of the African Methodist Episcopal Church (right). (Top: Michael Brooks; right: L.M. Arrigale.)

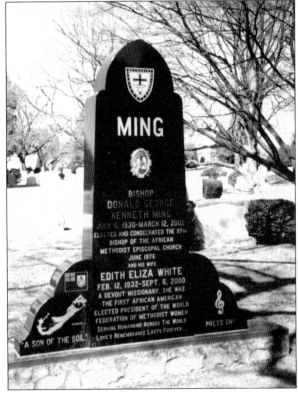

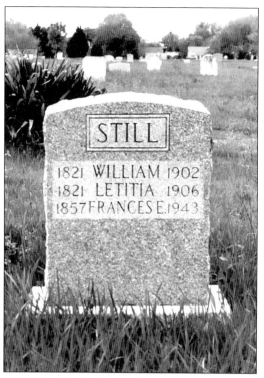

The oldest black-owned cemetery in America, Eden Cemetery was founded in Collingdale, Delaware County, in 1902. As African American cemeteries in Philadelphia were condemned by the city, Eden became the new home of the residents of Lebanon, Olive, and Stephen Smith Home Cemeteries. In 1902, abolitionist William Still was laid to rest in Eden (left). Still's interviews with former slaves—including one who turned out to be his long-lost brother Peter—grew into *The Underground Railroad*, published in 1872. Buried with him are his wife, Laetitia, and his daughter, Frances. Also buried in Eden is the Rev. Charles Albert Tindley (below), who before his death in 1933 composed over 60 hymns. One of them, "I'll Overcome Someday," served as the basis for the civil rights anthem "We Shall Overcome." This monument was erected on his unmarked grave in 2002. (L.M. Arrigale.)

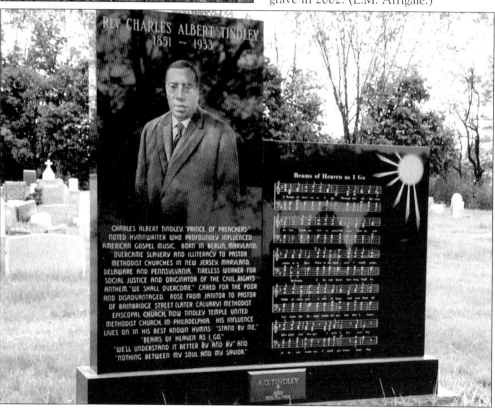

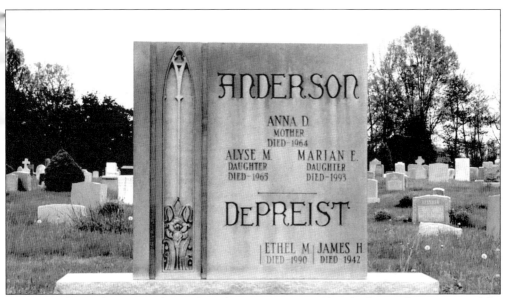

Marian Anderson (1897–1993) rose from the Union Baptist Church choir to become one of the world's finest opera singers and the first African American to perform at New York's Metropolitan Opera. In 1939, when the Daughters of the American Revolution refused to let her sing at Washington's Constitution Hall because of her race, Eleanor Roosevelt arranged for Anderson to perform at the Lincoln Memorial. Today, she lies in Eden Cemetery. (L.M. Arrigale.)

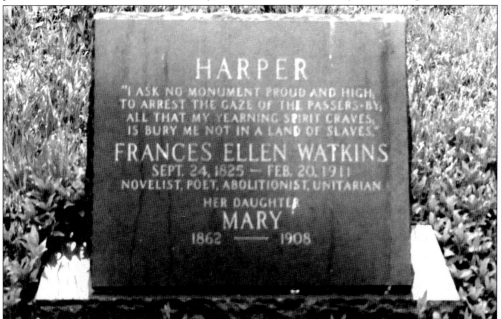

Frances Ellen Watkins Harper (1825–1911), known as the "Bronze Muse," was active in the Underground Railroad, cofounded the American Woman Suffrage Association and the National Association of Colored Women, and lectured for the Pennsylvania Anti-Slavery Society. Her book *Iola Leroy, or, Shadows Up-Lifted* may be the first novel by an African American woman. In 1992, a new marker of African granite, with a quote from her poem, "A Brighter Coming Day," was placed on her grave at Eden. (L.M. Arrigale.)

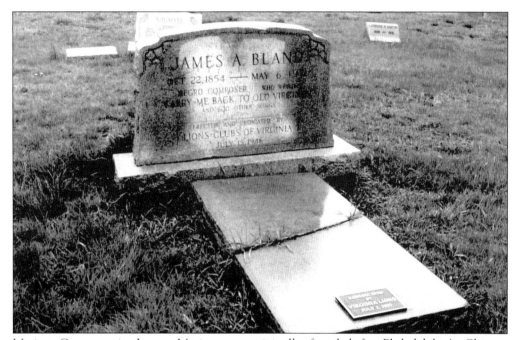

Merion Cemetery in Lower Merion was originally founded for Philadelphia's Chinese population but is now the resting place of many notable African Americans. James Bland (1854–1911) wrote "O Dem Golden Slippers," the Mummers' theme song; "Carry Me Back to Old Virginny;" "In the Evening By the Moonlight;" and 700 other songs, yet died destitute and alone. In July 1946, Dr. J. Francis Cooke, editor of *Étude* magazine, and the Lions Club of Virginia raised funds to erect a tombstone on his unmarked grave (above). State Representative David P. Richardson Jr. (1948–1995), community activist and lawmaker, also lies in Merion (below). Before his death, Richardson was the senior-ranking African American in the Pennsylvania House of Representatives. Today, Chelten Avenue in Germantown is also known as David P. Richardson Jr. Boulevard in his honor. (Ginny Warthen.)

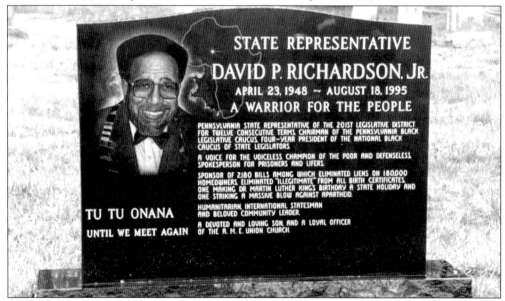

Seven
CATHOLIC AND JEWISH CEMETERIES

Like African Americans, Philadelphia's religious minorities were often excluded from established graveyards in the city's early years. For Catholics and Jews, however, separate burial in ground consecrated to their faiths was also seen as a religious requirement.

Most English colonies imported their mother country's restrictions against the open practice of Catholicism. Even in relatively tolerant Philadelphia, the public celebration of Catholic Mass was unknown until 1733, when St. Joseph's Church was founded. From then until 1759, St. Joseph's tiny churchyard was the only Catholic burial site in Philadelphia. (Before 1733, Catholics were buried in the southeast corner of the Strangers' Burial Ground.) Gradually, other Catholic churches and churchyards, such as St. Mary's, Holy Trinity, and St. Augustine's began to serve Philadelphia's growing Catholic population. As Philadelphia expanded during the 19th century, parish churches met the needs of Catholic neighborhoods in Frankford, Manayunk, and Germantown.

In 1849, Philadelphia's first diocesan cemetery, Cathedral, opened in West Philadelphia, followed by New Cathedral Cemetery in 1861. The original purpose of these cemeteries was not to provide an alternative to overcrowded parish cemeteries, but to raise funds through the sale of burial lots to finance construction of the Cathedral of SS. Peter and Paul on Logan Square. Burial within a Catholic cemetery was not mandatory; one of the Woodlands landmarks is the mausoleum of the Catholic Drexel family. The Catholic Church, however, strongly recommends that its members be buried in Catholic cemeteries, even if divorced or converted to another faith. Today, many practicing Catholics in the Philadelphia area still prefer burial in one of its parish or diocesan cemeteries.

The first Jewish burial site in Philadelphia was founded in 1738, when about a dozen Jews lived in the city. Two years later, the site of the current Spruce Street (Mikveh Israel) cemetery was acquired. Although Congregation Mikveh Israel was not formally established until the 1770s, it dates its beginning to the 1740 establishment of the cemetery. Today, Mikveh Israel oversees two other burial sites in addition to the Spruce Street cemetery.

Soon other congregations, such as Rodeph Shalom (founded in 1795 as America's first Ashkenazic synagogue) and Keneseth Israel, opened burial sites in rural areas like Kensington and Nicetown. Jewish burial societies, or *Chevras,* also founded burial sites, sometimes on consecrated ground within gentile cemeteries, such as the Chevra B'nai Belvue Shul within Kensington's Belvue Cemetery. By the late 1800s, independent Jewish cemeteries like Mount Sinai and Har Nebo were common.

Like their Christian counterparts, many Jewish cemeteries in Philadelphia have been closed, abandoned, or vandalized. In 1973, Rodeph Shalom relocated 1,206 bodies from its Kensington cemetery to the Roosevelt Memorial Park in Bucks County. More recently, discarded headstones from Mount Carmel Cemetery were used as props in a Halloween haunted hayride. Citing the belief that a paramount *mitzvah* (commandment or good deed) is to take care of the dead, the Association for the Preservation of Abandoned Jewish Cemeteries was organized in 1999 to restore endangered cemeteries, such as the Hebrew Mutual Burial Ground in southwest Philadelphia.

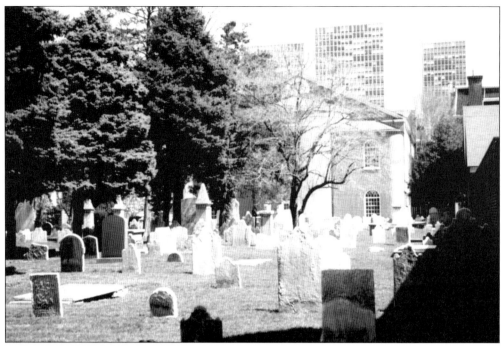

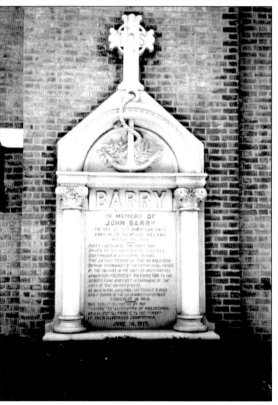

In 1763, 30 years after St. Joseph's was founded, a second Catholic church, St. Mary's, was built on the site of St. Joseph's Burial Ground on Fourth Street between Locust and Spruce. During the revolution, George Washington and John Adams attended services at the church, which was also Philadelphia's first cathedral from 1808 until 1859. Originally, worshippers entered St. Mary's through the graveyard (above); today, the main entrance is on Fourth Street. Commo. John Barry (1745–1803), the "Father of the American Navy" who rose from cabin boy to command the United States fleet, is buried under a granite slab in St. Mary's churchyard. A more elaborate monument to him decorates the church facade (left). Other notable residents of St. Mary's churchyard include Thomas Fitzsimons, signer of the Constitution; Stephen Moylan, George Washington's *aide de camp*; and publisher Matthew Carey. (L.M. Arrigale.)

92

Holy Trinity Church at Sixth and Spruce Streets was formed in 1788 by Philadelphia's German Catholics. The churchyard, which dates to 1791, is the imaginary resting place of the fictional Acadians, Evangeline and Gabriel, in the Henry Wadsworth Longfellow poem *Evangeline*. The small graveyard was quickly filled and was augmented by additional burial grounds on Fifth Street north of Spruce, and then on Eighth Street and Washington Avenue. (L.M. Arrigale.)

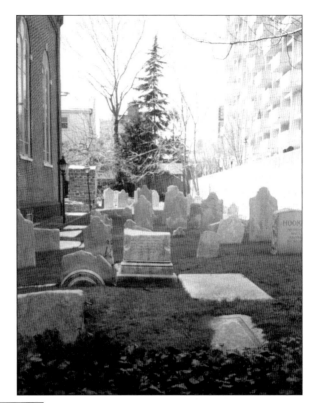

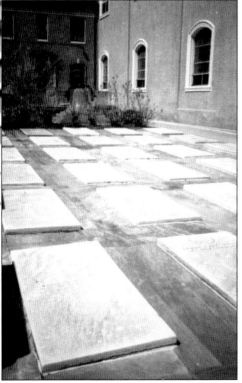

St. Augustine's Church at Fourth and Race Streets was established in 1796 to serve Irish Catholics in what was then North Philadelphia. In 1797, a burial ground was opened north of the church. The graves surrounding the church have been disturbed, moved, or covered over by such events as the church's burning in 1844 by anti-Catholic mobs, the construction of the Delaware River Bridge approaches in 1915, and the relocation of the parish house. Today, these family vaults lie south of the main church building. (L.M. Arrigale.)

In 1824, St. Joseph's Church opened a burial ground on the north side of Washington Avenue between Passyunk Avenue and Eighth Street. Although all remains were thought to have been removed to Yeadon's Holy Cross Cemetery in 1905, construction workers uncovered human bodies on the site in October 2001. Seventeen sets of remains were removed for analysis, after which they will be reinterred at Laurel Hill Cemetery. (Andy Waskie, Ph.D.)

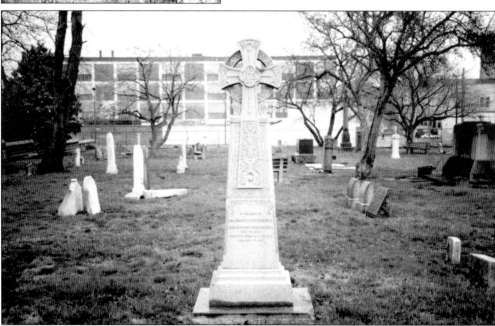

Philadelphia's rapid growth in the 19th century also necessitated the establishment of more parish churches and churchyards. St. Joachim's, founded in 1843 at the corner of Church and Franklin Streets in Frankford, served a predominantly Irish congregation. Today, there are about 50 parish cemeteries in the Philadelphia archdiocese, many of which are inactive.

In 1858, the Order of the Sisters of St. Joseph established a Catholic convent and girls' seminary (today Chestnut Hill College) in Chestnut Hill. The Sisters' Cemetery, which was moved twice because of construction during the 19th century, now overlooks the Wissahickon Creek. It holds the remains of 14 Sisters of St. Joseph who served as Civil War nurses at Camp Curtin and Church Hospital in Harrisburg, and on the hospital ships *Commodore* and *Whillden*. Mother St. John Fournier (1814–1875), whose grave bears a lily, the symbol of St. Joseph, did not actively serve as a nurse but guided the other 13. On September 20, 1924, a procession and ceremony was held to honor the Civil War nurses (below), with students from Mount St. Joseph's Academy and St. John's School for Boys in attendance. (Right: L.M. Arrigale; below: Sisters of St. Joseph.)

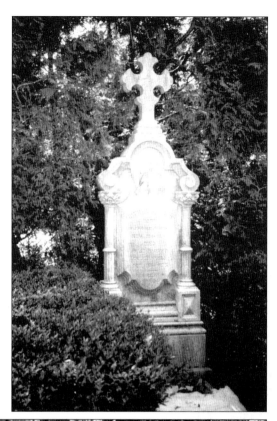

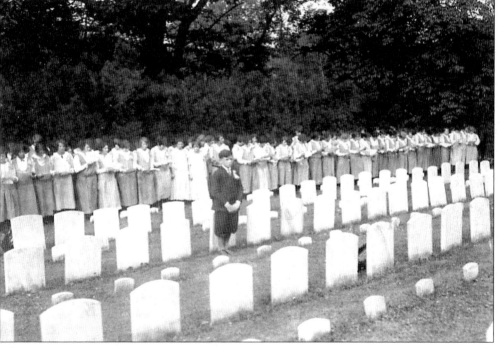

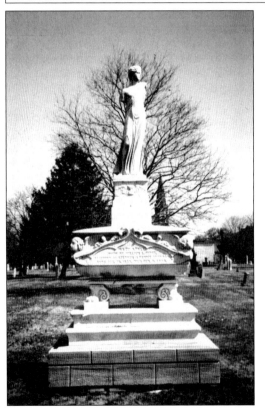

The Archdiocese of Philadelphia opened Cathedral Cemetery in 1849 at Forty-eighth Street and Lancaster Avenue in West Philadelphia. Besides providing an alternative to the city's parish churchyards, Cathedral Cemetery also generated revenues for the construction of the Cathedral of SS. Peter and Paul on Logan Square. As the early deed above shows, a double lot in Cathedral cost $30 in 1853. Open to all Catholics, Cathedral Cemetery was favored by the Irish families who then dominated Philadelphia's Catholic society, such as the Kellys, Redmonds, and Mulligans. The monument on the left commemorates Mary Adele, wife of lawyer and land speculator William L. Hirst, who died at age 33 in 1858. While statues of angels in Protestant cemeteries are usually female, those in Catholic cemeteries are often male, reflecting the importance of such archangels as Gabriel and Michael in the Catholic faith. (L.M. Arrigale.)

An avenue of family vaults runs along the southwest corner of Cathedral Cemetery. While some are built of marble or granite, several are brick (such as the Patrick J. McCarvey vault), indicating the importance of bricklaying and construction to the fortunes of Philadelphia's Irish. In 1861, a second diocesan cemetery, New Cathedral, opened at Second and Butler Streets in the city's Francisville section. Today, there are 12 diocesan cemeteries in and around Philadelphia. (L.M. Arrigale.)

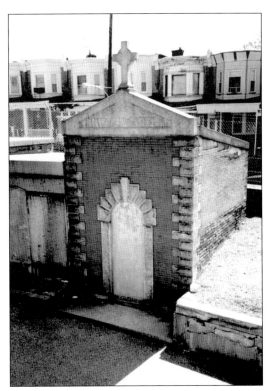

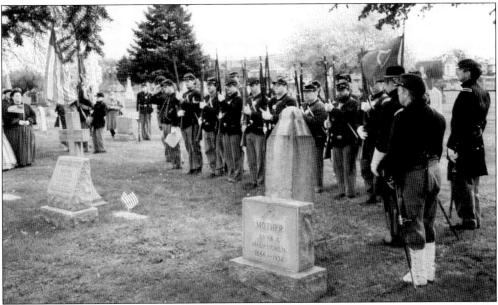

Cathedral Cemetery is home to over 50 members of the 69th Pennsylvania Irish Volunteers, which fought at Gettysburg and other major Civil War battles. Many were poor Irish immigrants whose families could not afford gravestones. The Volunteers, a Bucks County reenactment group, raised money to acquire and install markers at 18 unmarked graves. On Veterans Day 2002, the Volunteers honored the 69th Pennsylvania Irish at the installation ceremony. (69th Pennsylvania "Irish Volunteers.")

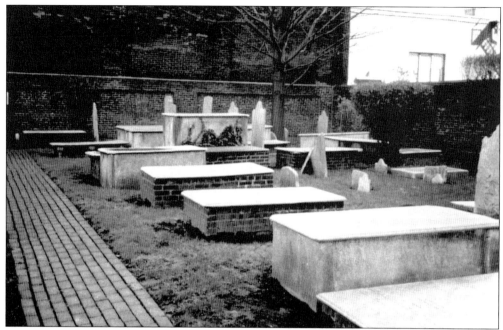

Founded in 1740, the first cemetery of Congregation Mikveh Israel (also known as the Spruce Street Burial Ground or *Kaal Kadosh Mickveh Israel*) originally served all of Philadelphia's Jewish population and holds members of the Levy, Gratz, Phillips, and Israel families. About 500 bodies were buried in the site, with only a few burials occurring after 1886. Among the monuments is a marble wall plaque carved by Moses Jacob Ezekiel, sculptor of the *Religious Liberty* statue near Mikveh Israel and the Anthony J. Drexel statue at Drexel University. The plaque below commemorates six of Ezekiel's ancestors buried in the ground, including Rabbi Eliezer Joseph Israel. In 1956, Congress declared the cemetery a National Historic Shrine and a unit of the Independence National Historical Park. Today, the cemetery is administered by the Mikveh Israel Cemetery Trust. (L.M. Arrigale.)

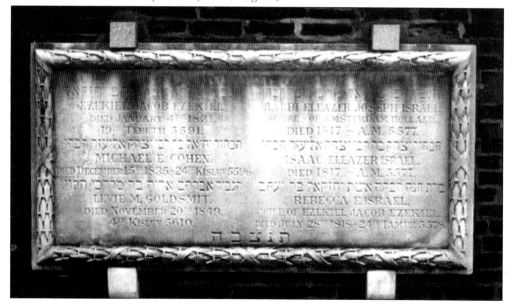

Rebecca Gratz (1781–1869), known as "the foremost Jewess of her day," organized or cofounded the Philadelphia Orphan Asylum, the Female Hebrew Benevolent Society, the Hebrew Sunday School Society, and many other social and educational institutions. Famous for her wit, charm, and beauty, she inspired the character of Rebecca in the Walter Scott novel *Ivanhoe*. This Frank Taylor sketch shows her grave at Mikveh Israel in the early 1900s.

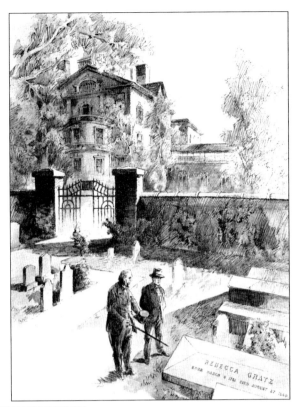

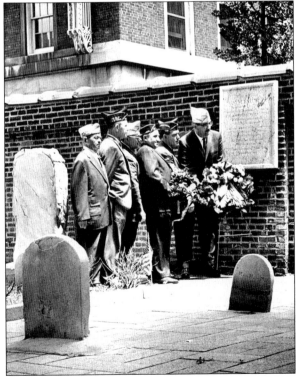

Haym Salomon (1740–1785), patriot and financier of the American Revolution, supported Robert Morris and the Revolutionary Government Office of Finance. He died a pauper and was buried in an unmarked grave in an unknown location at Mikveh Israel. In 1917, his great-grandson William installed a commemorative tablet on the east wall. This 1961 photograph shows Jewish war veterans lying a wreath at the plaque on Memorial Day. (Urban Archives, Temple University.)

In 1841, Congregation Mikveh Israel purchased a second burial ground on Federal Street between Eleventh and Twelfth Streets. Among those buried here are publisher Alfred Hart; rabbi and educator Sabato Morais; Judge Mayer Sulzberger; and numerous soldiers from the War of 1812, Mexican-American War, and Civil War. In 1847, Napoleon Le Brun (who also designed the Academy of Music and the Cathedral of SS. Peter and Paul) designed the cemetery entrance and *Metaher* (purification), the house for the ritual preparation of the dead. The Federal Street façade is shown above *c.* 1900. The view below shows the rear of the building, looking north through the cemetery toward Federal Street. The dilapidated structure was demolished *c.* 1990, prior to the cemetery's restoration. (Above: Library Company of Philadelphia; below: Congregation Mikveh Israel.)

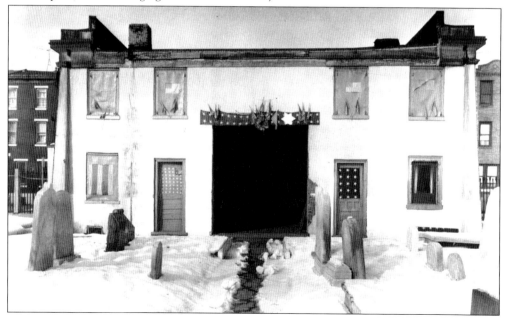

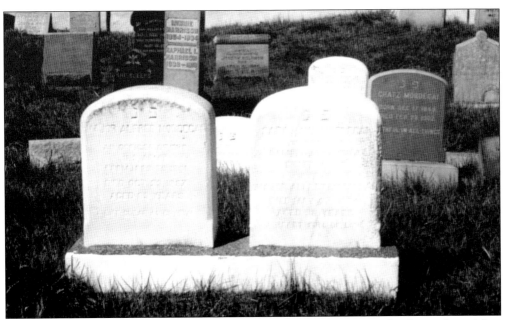

Among those buried on Federal Street are Alfred Mordecai (1804–1887), who graduated first in his West Point class at age 19. As assistant to the secretary of war and the chief of ordnance during the 1840s, he instituted scientific testing of munitions and weapons systems. He also authored the first ordnance manual that standardized the manufacture of weapons with interchangeable parts. A native North Carolinian, he resigned from the army in 1861 rather than fight his Southern relatives. (L.M. Arrigale.)

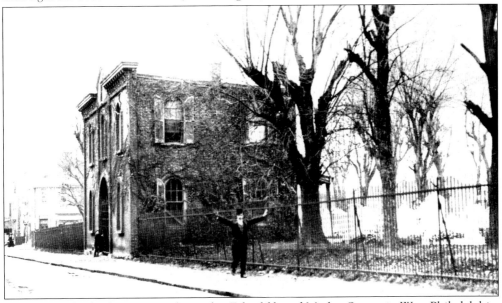

Mikveh Israel's third cemetery is located at Fifty-fifth and Market Streets in West Philadelphia. It was opened in 1850 by Congregation Beth El-Emeth, a breakaway group from Mikveh Israel founded by rabbi and educator Isaac Leeser (1806–1868), who is buried there. In 1895, Beth El-Emeth turned the property over to Mikveh Israel. This 1909 photograph shows the cemetery gatehouse. The cemetery is still active today. (Library Company of Philadelphia.)

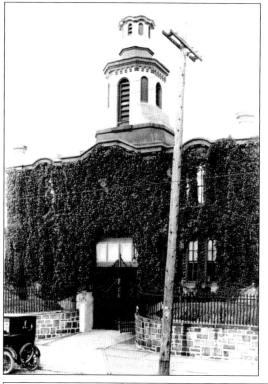

In 1853, Mount Sinai Cemetery was opened as the first non-Congregational (not affiliated with, or restricted to members of, a single congregation) Jewish cemetery in Philadelphia. Located on Bridge Street in Frankford, Mount Sinai boasted elaborate structures, such as the gatehouse (shown on the left c. 1910) and the mortuary chapel, designed in 1891 by legendary architect Frank Furness (shown below in a 1902 *Jewish Exponent* advertisement). Among those buried at Mount Sinai are Moses Annenberg, publisher of the *Philadelphia Inquirer* and father of the late diplomat and philanthropist Walter Annenberg; and the Gimbel brothers, founders of Gimbel's Department Store. Other non-Congregational cemeteries soon appeared in and around Philadelphia, including Har Nebo, Har Zion, Mount Carmel, and Montefiore. (Left: Library Company of Philadelphia; below: Historical Society of Pennsylvania.)

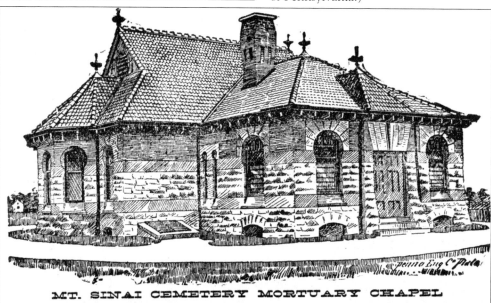

MT. SINAI CEMETERY MORTUARY CHAPEL

The advantages and facilities offered by the Mount Sinai Cemetery Association to their lot holders are superior to any provided by other cemeteries. A Mortuary Chapel, with well-furnished parlors for ladies and gentlemen, and a Receiving Vault have recently been added. Platforms are provided around the graves. Awnings are supplied in inclement or hot weather. A number of lots are now being laid out in the new part around the chapel. Plans of the ground can be seen and lots selected by applying to DAVID TELLER, President, 903 North Eighth Street; WM. B. HACKENBURG, Vice President, 516 Market Street, or to OSCAR B. TELLER, Secretary, 606 Chestnut Street.

- The Second and Third, and Fifth and Sixth Street cars carry passengers to the terminus at Bridge Street (two squares from cemetery), or by taking cars on Tacony Branch, passengers can ride direct

(e.o.w.)

While many Jewish congregations and cemeteries relocated to the suburbs after World War II, a number remained in Philadelphia. Shown here is the funeral of Rabbi Bernard Levinthal outside the B'nai Abraham Synagogue at 521–523 Lombard Street on September 24, 1952. Levinthal, the chief Orthodox rabbi of Philadelphia, was buried at the Mikveh Israel (Beth El-Emeth) Cemetery at Fifty-fifth and Market Streets. (Urban Archives, Temple University.)

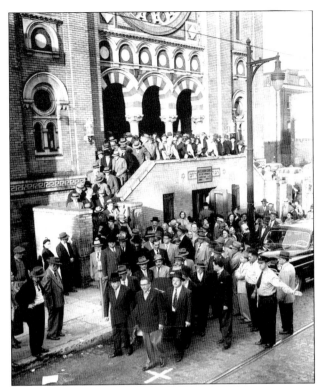

Roosevelt Memorial Park was founded in 1928 in Trevose, Bucks County, north of Philadelphia. Roosevelt was the first Jewish cemetery in the region to adopt such features as in-ground bronze markers and above-ground mausoleums. In 1972, Roosevelt opened the Garden of Hagannah, a community mausoleum for Jewish war veterans. Several historic Philadelphia cemeteries have been relocated to Roosevelt, including Rodeph Shalom and Beth Israel (Arabella). (Urban Archives, Temple University.)

After years of neglect, the B'nai Israel or Hebrew Mutual Burial Ground in the Eastwick section of West Philadelphia is being reborn. In 1857, Dutch Jews who had recently formed the B'nai Israel Congregation purchased a half-acre plot from Mount Moriah Cemetery for their burial site. When the congregation disbanded, the cemetery was taken over by the Hebrew Mutual Burial Society. Abandoned after 1970, the cemetery became a trash-filled eyesore. In 1999, the Association for the Preservation of Abandoned Jewish Cemeteries was formed to rescue Hebrew Mutual, under the auspices of the Board of Rabbis and the Jewish Federation of Greater Philadelphia. In 2000, the association was granted ownership of Hebrew Mutual and initiated a $400,000 restoration project, removing trash, cutting down trees, restoring monuments, landscaping, and rebuilding walls. (Stanley Barer, Association for the Preservation of Abandoned Jewish Cemeteries.)

Eight
The Trappings of Death

By the late 19th century, Philadelphia was America's third largest city and the "workshop of the world." According to the 1870 Census, Philadelphia had 8,184 factories, compared to 7,624 in New York City and a mere 4,479 in St. Louis. Not surprisingly, many Philadelphia factories supported the booming business of death that provided its cemeteries with a steady flow of customers.

Dozens of marble yards produced not just mantelpieces and front steps for Philadelphia's countless row houses, but monuments for its 50 active cemeteries. Victorian lithographs and stereo views show marble yards filled with obelisks and tombstones, such as the Henry S. Tarr Monument Company on Green Street and the Baird Monumental Works in Spring Garden, as a common feature of street life. These yards competed with the Philadelphia White Bronze Company, whose supposedly indestructible zinc monuments enjoyed a brief popularity in the late 1800s.

Every imaginable funereal product was manufactured by Philadelphia companies. The Stein Casket Manufacturing Company created luxurious caskets for U.S. Grant and other notables. Artificial flowers for funerals and grave decorations came from the Philadelphia Immortelle Company. The Brill Company built special funeral cars for trolleys on Arch Street and for railroads in Brazil. Although embalming was not common until after the Civil War, Dr. Ellerslie Wallace of Jefferson Medical College had developed an early embalming method by 1846. Later, the local firm of H.S. Eckels became a leading supplier of embalming chemicals and supplies.

Philadelphia also boasted numerous undertakers, some dating back to before the American Revolution. Most began as furniture makers who produced coffins on the side. During the 19th century, they expanded their services beyond coffin building to preparing the corpse and providing all the materials required for a proper funeral. Some undertakers, such as African American Robert Bogle, were also caterers, servicing the living and the dead with, in the words of Nicholas Biddle, "the wedding cake, the funeral crape,/The mourning glove, the festive grape." In 1864, the Undertakers' Mutual Protective Association was founded in Philadelphia, signalling the city's central role in the industry's development.

Only a consummate professional could handle the myriad details of an elaborate Victorian funeral, from the horse-drawn hearse (with the number of plumes signifying the status of the deceased) to the crepe door hangers that identified a house of mourning. The funeral ceremonies for a major celebrity could involve hundreds of participants and cost thousands of dollars. For the 1872 funeral of Gen. George Gordon Meade, a funeral barge transported the casket from Fairmount Water Works up the Schuylkill to Laurel Hill Cemetery, escorted by dozens of sculls from Philadelphia rowing clubs. The entire affair cost $598.68, nearly twice the annual salary of the average worker.

The scope of General Meade's funeral would not be matched until the funeral of Frank Rizzo in July 1991. Prior to the former mayor's burial at Holy Sepulchre Cemetery, the line of mourners waiting to view his body at the Cathedral of SS. Peter and Paul stretched from Logan Square down the Benjamin Franklin Parkway to city hall.

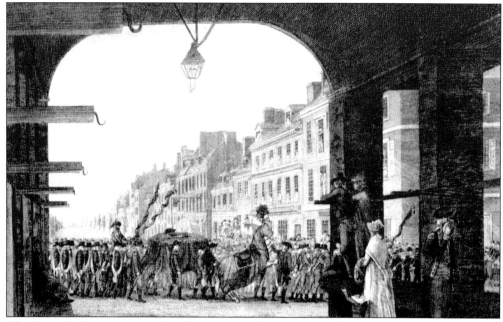

The funerals of statesmen and military heroes always prompted elaborate shows of mourning. After former president George Washington died at Mount Vernon in December 1799, a memorial procession decreed by Congress assembled at the state house (Independence Hall) and proceeded to Zion Lutheran Church. This William Russell Birch engraving shows the empty bier and unmounted horse, draped in black, proceeding north on Fourth Street past the market sheds on High (Market) Street.

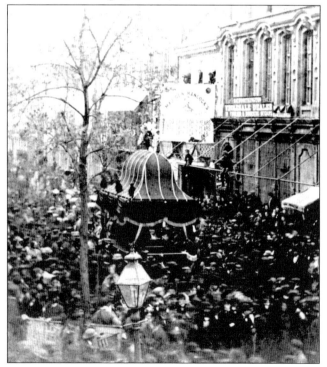

After Abraham Lincoln was assassinated, Philadelphia was the third stop of 11 cities for his body on its trip to Springfield, Illinois. This stereo view shows the elaborate hearse bearing Lincoln's body at Sixth and Chestnut Streets on April 22, 1865. Riots broke out as 300,000 people lined up to view Lincoln's body lying in state at Independence Hall before it proceeded to New York City. (Library Company of Philadelphia.)

During the 19th century, dozens of marble masons created monuments for Philadelphia cemeteries. Foremost among them was Scottish immigrant John Struthers, whose yard was located at 360 High (Market) Street. Struthers carved the monument for Commo. Isaac Hull at Laurel Hill (see page 25), the new sarcophagi for George and Martha Washington at Mount Vernon, and the sarcophagus for the "Great Compromiser" Henry Clay (seen above in an 1861 stereo view) that now lies in the Clay Monument in Lexington, Kentucky. Struthers was also chief marble mason on such William Strickland buildings as the Merchants' Exchange and the Second Bank of the United States. At the opposite end of the scale were the small masons located near neighborhood cemeteries (below), such as M. Herb's marble yard at Northwood Cemetery in Oak Lane. (Above: Library Company of Philadelphia.)

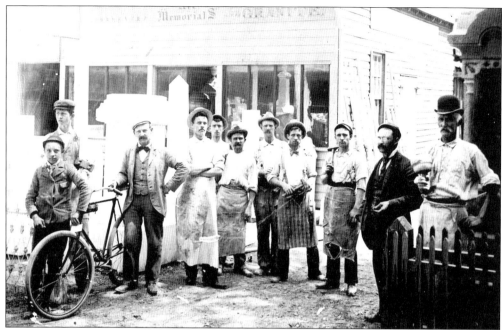

H.C. Wood Memorials is Philadelphia's oldest continuously family-owned monument business, now run by the fifth generation of Woods. Founded by Aaron Wood in 1848, it was originally located at Thirty-third and Market Streets. In 1896, the company moved to Baltimore Pike in Lansdowne, opposite Fernwood Cemetery. Shown above is the staff from that period, with principal owner J.F. Wood, second from the right, and his brother Harvard (grandfather of the current owner), third from the left. A macabre story lies behind one of the Wood monuments, the Friend marker at Fernwood Cemetery (below). Gilbert Friend, author of the poem in the center of the monument, lost his wife Marianne in 1932. A year later, unable to deal with the loss of his "sweetheart wife," he killed his three children and then took his own life. (H.C. Wood Memorials, Harvard C. Wood III.)

One of H.C. Wood Memorials' best-known monuments is *The Bicycle Boy*. Carved in 1896, it marked the grave of Norman Van Kirk, who overheated himself riding his beloved bicycle, fell into a horse trough, and later died of pneumonia. Carved by Thomas H. Wood, the monument adorned the firm's early billheads (above). Several years ago, Fernwood Cemetery asked the company to remove the weathered, broken statue (right). Today, the recarved boy adorns H.C. Wood's Baltimore Avenue showroom, missing his right arm but otherwise looking much as he once did. One elderly lady told the owner that when she visited Fernwood as a child, she loved *The Bicycle Boy* because it was her own age and size, but hated it because her father used it as a reason why she shouldn't ride a bike. (H.C. Wood Memorials, Harvard C. Wood III.)

Most of Philadelphia's undertakers started as furniture or carriage makers. Two of the city's oldest undertakers were Andrew J. Bair and Son (shown above at 1837 Arch Street in the 1880s) and R.R. Bringhurst and Company, at 1924 Arch Street. The two firms, both founded in 1822, merged in 1972. R.R. Bringhurst, in particular, was Philadelphia's carriage-trade undertaker, handling the funerals of such notables as George Gordon Meade and John Wanamaker, and the reinterment of Betsy Ross from Mount Moriah to the Betsy Ross House in 1975. By the 1940s, the horse-drawn carriage above had given way to the limousine hearse below. William A. Sickel, standing in front of the hearse, would acquire the merged Bringhurst-Bair firm in 1976 along with his partner, H. Blair Anthony. (H. Blair Anthony and William A. Sickel, R.R. Bringhurst and Company.)

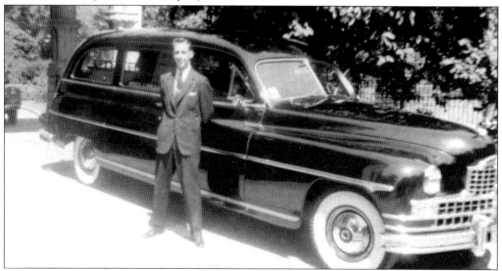

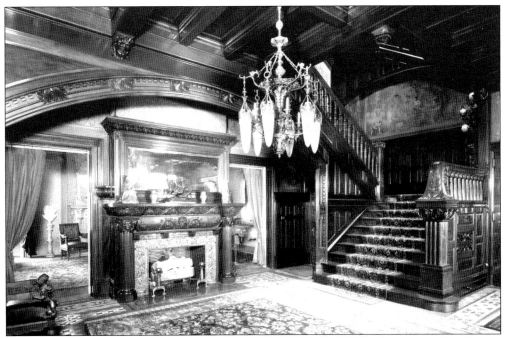

In 1926, Andrew J. Bair and Son moved from Arch Street to 3925 Chestnut Street in West Philadelphia. The lavish mansion once belonged to William J. Swain, founder of the *Public Record* (see page 45). Mourners entered the entrance hall (above) and ascended to the second floor for funerals. After these photographs were taken c. 1930, the wooden stairs were replaced with marble steps to eliminate creaking. Much of the mansion's elegant decor was tendered as payment by cash-strapped customers during the Depression. The servants' quarters on the third floor became the casket showroom (below). The merged Bringhurst-Bair firm stayed at 3925 Chestnut Street from 1972 until 1980. Today, R.R. Bringhurst and Company is affiliated with West Laurel Hill Cemetery, while the Swain mansion is the Ronald McDonald House. (H. Blair Anthony and William A. Sickel, R.R. Bringhurst and Company.)

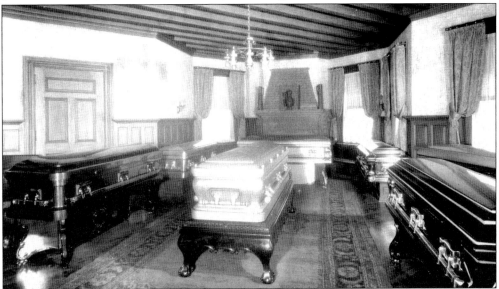

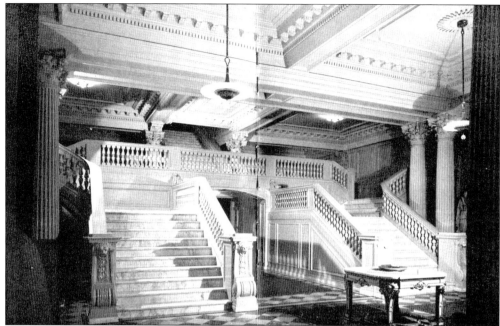

An Artistic Corner in the Main Reception Hall

Oliver H. Bair Company was founded in 1891 by a brother of Andrew J. Bair. Oliver Bair pioneered the use of "pre-need financing," with policyholders paying for their funerals in weekly five- and ten-cent increments. These policies helped to finance the construction of a lavish building at 1820 Chestnut Street, said to be the first structure built specifically as a funeral parlor. The photograph above, from a 1930s sales brochure, shows the grand staircase leading from the reception hall to the organ hall. On the left is "an Artistic Corner in the Main Reception Hall." In the 1990s, the firm moved first to 1920 Sansom Street, and then to Montrose Cemetery in Upper Darby. Today, the Chestnut Street building houses Boyd's Clothing Store.

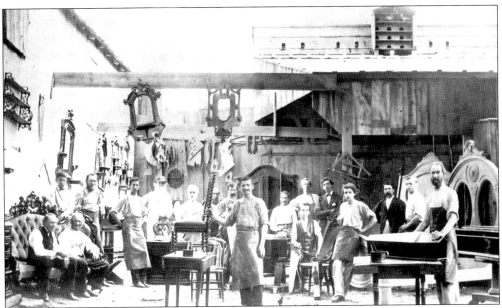

Kirk and Nice may be the oldest undertaking establishment in continuous existence in the United States. Founded by cabinet and coffin maker Jacob Knorr, the business buried soldiers killed at the Battle of Germantown in October 1777. During the early 1800s, it was acquired by members of the Kirk and Nice families. The photograph above shows the firm's carpentry shop in the 1860s, when it still manufactured furniture in addition to coffins. Shown below is the Kirk and Nice complex c. 1917 at the northeast corner of Germantown Avenue and Washington Lane, where it had been located since Colonial days. In 1993, Kirk and Nice was acquired by Stewart Enterprises. Six years later, it moved from its historic Germantown location to the George Washington Memorial Park in Plymouth Meeting. (Kirk and Nice.)

In the 19th century, every major department store had a special department to sell mourning clothes and furnishings to the recently bereaved. Widows were expected to dress all in black for the first year and graduate to shades of gray, violet, and white during the second year. During the first year, only flat, unshiny fabrics, like wool or bombazine were allowed. After that, widows could wear silk or crepe de Chine. Jewelry made of jet, ivory, or the hair of the deceased was also de rigueur. Today, mourning jewelry is an extremely popular collectible.

Between 1912 and 1930, the Philadelphia Rapid Transit Company (PRT) offered a special trolley car for funerals. The Brill-manufactured *Hillside* had an outside trap door for caskets, seated 40 mourners, and boasted black curtains, black leather seats, and silver decorations. The *Hillside* ran up Arch Street (between Andrew J. Bair and R.R. Bringhurst) to Hillside Cemetery in Roslyn, although it was occasionally used by other cemeteries. (Miller Library, Pennsylvania Trolley Museum.)

Nine
VANISHED CEMETERIES

From the beginning of Philadelphia's history, the need to venerate the city's dead has battled with the need to provide its living with space for housing, commerce, and recreation. The living—who vote and pay taxes, and occasionally bribe—usually win the battle.

Philadelphia's rapid growth during the 19th century ensured that rural cemeteries quickly became urban cemeteries, surrounded by dwellings and factories. As development pressures increased, state and city governments achieved greater power to acquire and obliterate burial sites. Starting in the 1870s, a series of laws enabled municipal governments to stop burials in private cemeteries, to declare neglected graveyards public nuisances and order their removal, to restrict the opening of new cemeteries in built-up areas, and to open or widen streets through existing cemeteries. Other laws made it easier for religious organizations to dispose of inactive graveyards.

Lot holders who thought that their cemetery deeds permanently shielded their family's remains from any future disturbance were quickly disillusioned. Once notified that a cemetery had been acquired for other purposes, lot holders had the right to remove their family members and monuments to another cemetery of their choosing. Unclaimed bodies were moved to a court-appointed site, and their monuments were trashed. While removals were supposed to be handled respectfully, political corruption and ineptitude often made a ghoulish mockery of the process.

Although Philadelphia's cemeteries have been disappearing throughout its history, there have been three large waves of demolition. From 1865 to 1895, as Center City grew highly industrial and open areas were built up, many churchyards and cemeteries vanished, including the Welsh Burying Ground (1864), Zion Lutheran (1866), Second Presbyterian (1867), First German Reformed (1882), First Baptist (1889), First Moravian (1890), and Machpelah (1895).

The period from 1910 to 1926 saw many churches abandon their decaying inner city sites and move to the suburbs, including All Saints', Blockley Baptist, Ebenezer Methodist Episcopal, and St. John's Evangelical Lutheran. Other neglected cemeteries were condemned by the city, such as Hanover, Olive, and the Mutual Burying Ground.

After World War II, political pressure for urban renewal replaced many historic cemeteries with playgrounds, parking lots, and supermarkets between 1945 and 1970. During this period, Philadelphia lost Lafayette (1947), Franklin (1950), Ronaldson's (1950), Belvue (1951), Odd Fellows (1951), United American Mechanics (1951), Monument (1956), St. Mary's Cemetery (1956), German Lutheran (1969), and the Union Burial Ground (1970).

The corruption and callousness attending the cemetery removal process hit unplumbed depths after World War II. Its heritage can still be seen today. Go to the Delaware River near Castor Avenue in Frankford at low tide and study the dozens of tombstones from Monument Cemetery visible in the murky water. Stop by the former site of the Raymond Rosen housing project and wonder how many bodies from Odd Fellows and United American Mechanics Cemeteries still remain there. Or visit a Neshaminy strip mall near Route 1 and meditate on a small granite slab that indicates where nearly 50,000 Philadelphians uprooted from their "final resting places" were secretly dumped.

Machpelah Cemetery (shown c. 1874), on the north side of Washington Avenue between Tenth and Eleventh Streets, was established in 1832. Among those buried there was John Augustus Stone, Philadelphia dramatist and author of *Metamora*, whose monument was paid for by his friend, the actor Edwin Forrest. In 1895, Machpelah was sold, and its bodies were moved to Graceland (North Mount Moriah) Cemetery in Yeadon, which was later abandoned. (Historical Society of Pennsylvania.)

Founded in 1827 in Moyamensing, Ronaldson's Cemetery was one of Philadelphia's first independently owned and nonsectarian cemeteries. In 1924, the dilapidated cemetery was inspected by Charles Hall, president of the city council, and Mayor W. Freeland Kendrick for a possible playground site. In 1950, its 13,500 inhabitants were transferred to a mass grave at Forest Hills Cemetery in Somerton, and its land finally became a city playground. (Urban Archives, Temple University.)

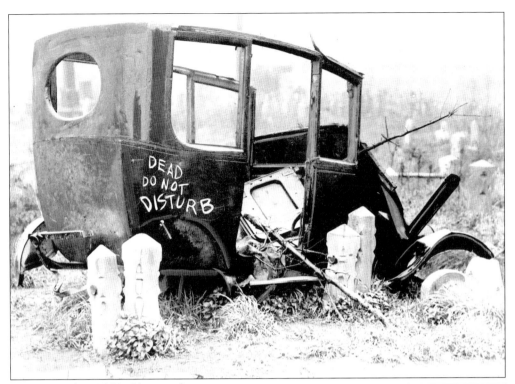

Incorporated in 1850, Glenwood Cemetery stood at Ridge Avenue and Twenty-seventh Street in a rural North Philadelphia neighborhood that soon became highly industrial. After the last interment took place in 1921, the cemetery degenerated into a dumping ground (above). Glenwood's landmark was the Scott Legion Monument, marking the graves of soldiers who fought in the Mexican-American War under Lt. Gen. Winfield Scott. In 1927, the American Legion arranged to have the monument and the bodies of 61 of Scott's soldiers moved to the National Cemetery in Germantown, where they rest today (right). After years of community protests, the rest of Glenwood's remains were removed to Glenwood Cemetery in Broomall in 1938. Roads were cut through the cemetery site, and the Philadelphia Housing Authority's first low-rent housing project was erected on the site. (Above: Urban Archives, Temple University; right: L.M. Arrigale.)

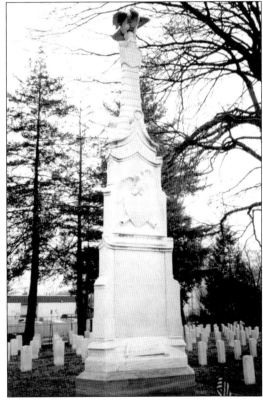

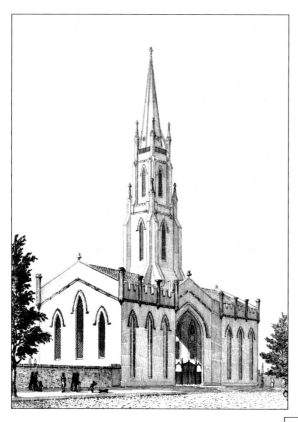

Philadelphia's second rural cemetery after Laurel Hill was founded on Broad Street in North Penn Township (today North Philadelphia) in 1837 by Dr. John Elkinton. Originally named Père-Lachaise after the Parisian cemetery, its name was changed to Monument Cemetery when a central monument to George Washington and the Marquis de Lafayette was proposed. Due to financial problems, the obelisk was not erected until 1869. John Sartain (1808–1897), eminent Philadelphia artist and engraver, designed the monument as well as the cemetery's soaring Gothic gatehouse and chapel. This structure was demolished in 1903, when Berks Street was cut through the cemetery.

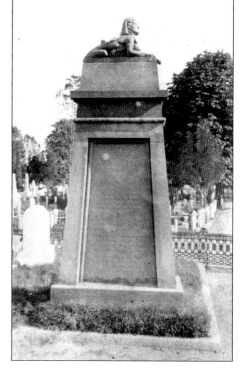

Sartain, who served as a cemetery officer for many years, also designed the unusual monument for his family lot, topped by an Egyptian sphinx. (Pennsylvania Academy of the Fine Arts. Archives. William Sartain Scrapbooks.)

In 1956, Temple University (located across Broad Street) purchased Monument Cemetery for a parking lot and playing fields. About 28,000 bodies—including that of Civil War nurse Anna M. Ross—were removed to Lawnview Cemetery in Rockledge (below). According to one observer, the hot summer weather resulted in "many days when the odors in the air were well-nigh intolerable." Most of the monuments, including the central obelisk to Washington and Lafayette designed by John Sartain (right), were dumped in the Delaware River near Castor Avenue as riprap (foundation) for the Betsy Ross Bridge, then under construction. At low tide today, many of the grave markers are still clearly visible. Among the surnames that have been recorded on the submerged monuments are those of Monument's early officers, Elkinton and Sartain. (Right: Urban Archives, Temple University; below: Historical Society of Pennsylvania.)

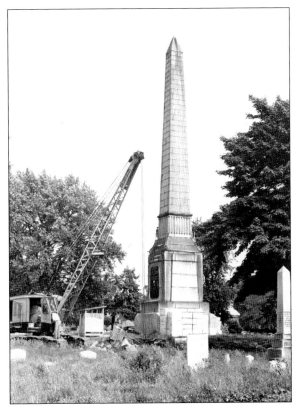

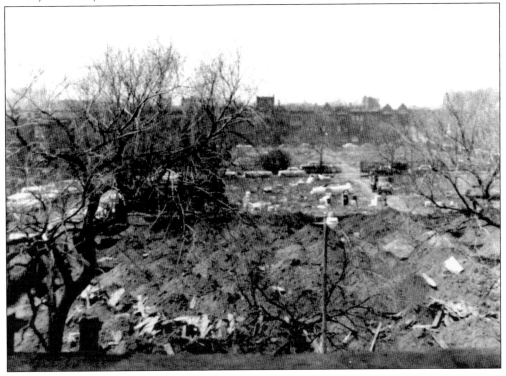

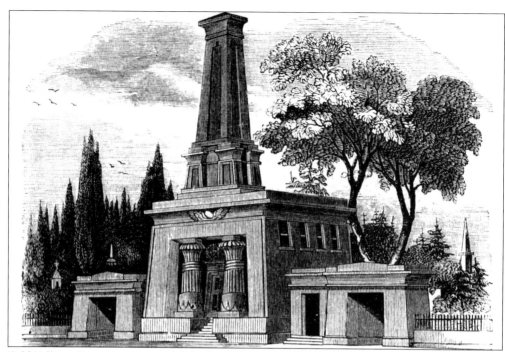

Odd Fellows Cemetery was established in 1849 near present-day Diamond and Twenty-fourth Streets. Thomas Ustick Walter, who designed Girard College and the dome of the United States Capitol, created an imposing Egyptian temple for its gatehouse (above). Many lodges of the Odd Fellows, a 19th-century fraternal organization, purchased lots in the cemetery. During the Civil War, soldiers from the Mower Hospital in Chestnut Hill and McClellan Hospital in Nicetown were also laid to rest here. George Lippard, author of such sensational novels as *The Quaker City* and founder of one of America's first labor unions, was buried in Odd Fellows in 1854. In 1886, members of his union, the Brotherhood of America, erected this elaborate monument over his grave. (Above: James Hill Jr.; below: Historical Society of Pennsylvania.)

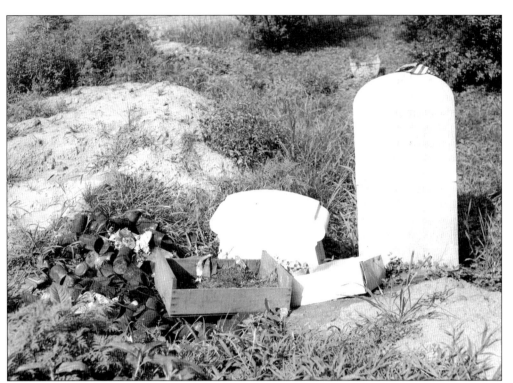

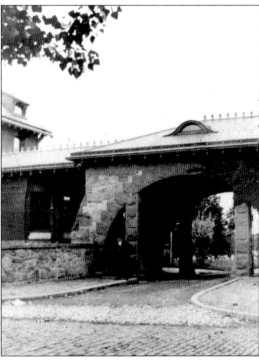

By the 1940s, trash covered many of the graves at Odd Fellows, including that of Civil War veteran Richard A. Thomas (above). In 1950, the Philadelphia Housing Authority acquired both Odd Fellows and the neighboring United American Mechanics Cemetery (whose gatehouse is seen on the left c. 1891). About 85,000 bodies were removed from the two cemeteries and moved to Mount Peace and Lawnview Cemeteries, both of which are also owned by the Odd Fellows. (Today, George Lippard and his monument reside at Lawnview.) The Raymond Rosen housing project was erected on the site, although contemporary newspaper articles reported delays and cost overruns because of bodies left there. When the Rosen complex was demolished in 1999, there were further reports of caskets and human remains being uncovered. (Above: Urban Archives, Temple University; left: Historical Society of Pennsylvania.)

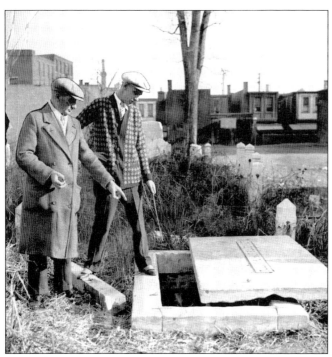

Franklin Cemetery at Elkhart and Helen Streets in Kensington had been used as a burial site as early as 1800. By 1932, it had become a "hangout for disorderly persons," and one tomb served as a hiding place for thieves. In 1947, over 8,000 bodies were removed from Franklin to suburban cemeteries, and the site became a playground. Today, however, the location of many of these bodies remains a mystery. (Urban Archives, Temple University.)

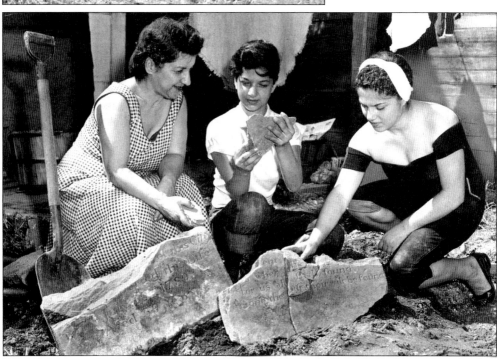

Dig a hole in much of old Philadelphia and you're likely to hit somebody's grave. That's what happened in 1954 to South Philadelphia resident Yolanda Roselli, shown here with her daughters Antoinette and Mary. While digging in her backyard at 431 Daly Street (between Fourth and Fifth Streets, near Mifflin Square), Roselli unearthed fragments of 18th-century tombstones from a long-vanished graveyard. (Urban Archives, Temple University.)

Old Oaks Cemetery was founded in 1869 on a tract of land south of Abbotsford Avenue and west of Wissahickon Avenue in East Falls. Its showcase monument commemorated David M. Lyle, chief engineer of the Philadelphia Fire Department, who died in 1867, with a statue of him in uniform. Lyle had originally been buried in Odd Fellows Cemetery and was transferred to Old Oaks by a huge procession of fire companies. Old Oaks closed after only a few years, a victim of the area's rapid industrialization and its own marshy ground. In 1877, David Lyle and his monument were removed to Ivy Hill Cemetery in Mount Airy (above). In the 1930s, Lyle's statue was struck by lightning and shattered beyond repair (below). Today, only the base of his monument remains. (Ivy Hill Cemetery Company.)

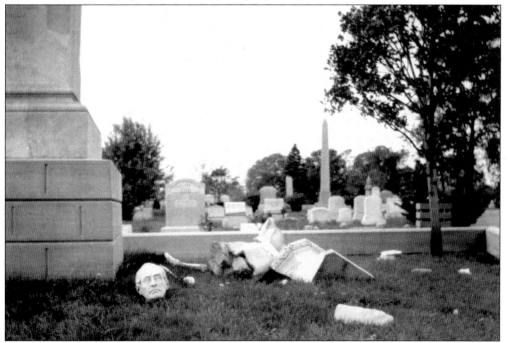

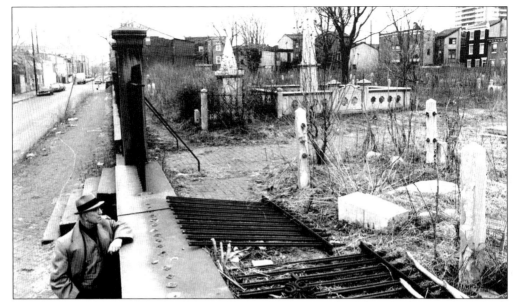

The Union Burial Ground, at the northeast corner of Sixth and Federal Streets in South Philadelphia, was incorporated in 1841 as an "association" cemetery. These cemeteries, which included Machpelah and the Mutual Burying Ground, catered to poorer Philadelphians, who, as association members, could obtain a decent family plot for $10. At one time, Union was called "Sixth Street Union" to differentiate it from another Union Burial Ground at Tenth Street and Washington Avenue. In 1970, the cemetery, which contained the graves of roughly 100 Civil War soldiers and sailors and their families, was neglected and vandalized (above). That year, the site was sold for use as a supermarket. About 2,000 graves were dug up, the remains boxed and then reburied in Philadelphia Memorial Park in Frazer, Chester County (below). (Urban Archives, Temple University.)

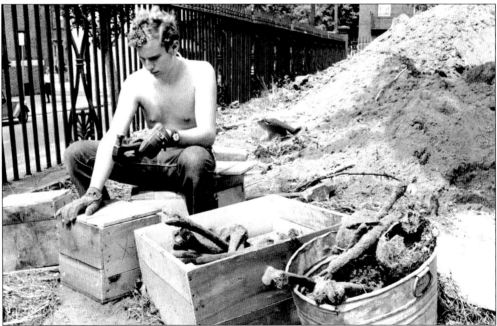

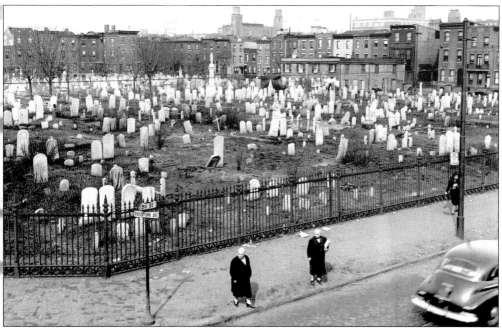

In 1839, Lafayette Cemetery was established in Moyamensing (today part of South Philadelphia) on the block bordered by Ninth, Tenth, Federal, and Wharton Streets. In 1946, Thomas A. Morris, owner of Evergreen Cemetery in Bucks County, was granted title to the Lafayette property in exchange for reburying its 47,000 occupants in Evergreen in new containers and with individual markers. After Democrats accused Morris of selling the property back to the city at an inflated price, Lafayette was condemned for use as a playground. In the resulting political scandal, the fate of the cemetery's inhabitants was forgotten. The photograph above shows Lafayette at the corner of Ninth Street and Passyunk Avenue in March 1946; the photograph below shows the site from the corner of Tenth and Wharton in November 1947, after the bodies were removed. (Urban Archives, Temple University.)

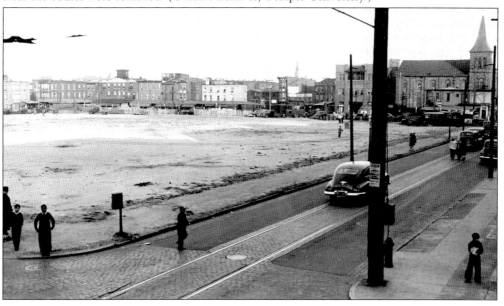

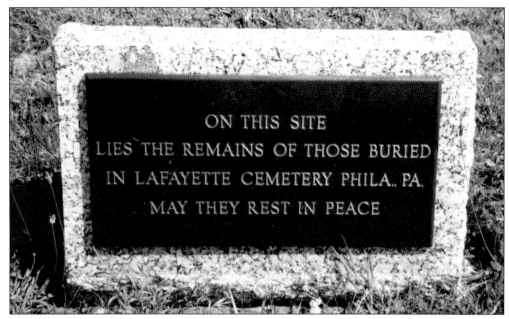

In 1988, construction workers excavating for a strip mall near Neshaminy Mall in Bensalem, Bucks County, discovered a number of unmarked graves. After further investigation, township officials concluded that remains from Lafayette Cemetery, and perhaps from Franklin Cemetery as well, had been buried in unmarked trenches. Today, this plaque is the only memorial to the 47,000 men, women, and children who once rested at Lafayette. (Bensalem Historical Society.)

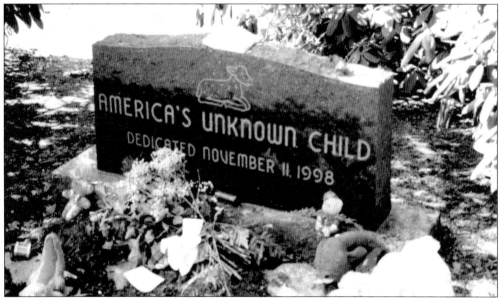

A society that abandons its cemeteries may have little trouble abandoning its children. In 1957, the nude, battered body of a young boy was found in northeast Philadelphia. Despite an extensive, ongoing investigation, the identities of the boy and his killer are still unknown. After being buried in the City Cemetery for 31 years, "America's unknown child" was reburied beneath this marker in Ivy Hill Cemetery in November 1998. (L.M. Arrigale.)

INDEX

African Episcopal Church of St. Thomas* 79, 81
All Saints' Church* 115
Arch Street Meeting House 9, 11, 21
Arlington (Upper Darby) 72

Belvue* 91, 115
Beth Israel (Arabella)* 103
Blockley Baptist Church* 115
Byberry Friends Meeting 65

Campbell A.M.E. Church 83
Cathedral 91, 96–97
Cedar Hill 49, 63
Chelten Hills 64
Chestnut Hill Baptist Church 72
Chestnut Hill United Methodist Church 72
Chevra B'nai Belvue Shul* 91
Christ Church 6, 9, 12, 15
Christ Church Burial Ground 6, 12, 13, 14
Church of St. James the Less 49, 60-61
Church of the Epiphany* 43
City Cemetery (Potter's Field) 126
Convent of the Sisters of St. Joseph 95
Crispin (Holme) Burying Ground 16

De Benneville Burial Ground 67

Ebenezer Methodist Episcopal* 115
Eden (Collingdale) 79, 81, 82, 84, 85, 88–89
Evergreen (Bucks County) 125

Fair Hill Burial Ground 6, 65, 74, 86
Fernwood (Lansdowne) 108, 109
First African Baptist Church* 82
First Baptist Church* 9, 115
First German Reformed Church* 115
First Moravian Church* 9, 115
Forest Hills 116
Frankford Presbyterian Church 77
Franklin* 115, 122, 126
Free Quaker Burying Ground* 53

George Washington Memorial Park (Plymouth Meeting) 113
German Lutheran Church* 115
Germantown Friends Meeting 66
Germantown Mennonite Church 70

Germantown Potter's Field* 65, 79
Glenwood* 49, 117
Gloria Dei (Old Swedes'/Wicaco) Church 10
Graceland (North Mount Moriah, Yeadon)* 116
Greenwood (Knights of Pythias) 49, 56–57

Hanover* 115
Har Nebo 91, 102
Har Zion (Collingdale) 102
Hebrew Mutual Burial Ground (B'nai Israel) 6, 91, 104
Hillside (Roslyn) 115
Historic Bartram's Garden 80
Holy Cross (Yeadon) 94
Holy Sepulchre (Cheltenham) 105
Holy Trinity Catholic Church 91, 93

Ivy Hill Cemetery 58–59, 87, 123, 126

Keneseth Israel* 91

Lafayette* 115, 125–126
Laurel Hill 2, 6, 21–34, 35, 49, 94, 105, 107
Lawnview (Rockledge) 119, 121
Lebanon* 79, 81, 84, 88
Leverington 65, 73
Logan Burying Ground (Stenton)* 67
Lombard Street Central Church* 83
Lower Burying Ground/Hood Cemetery 65, 67, 68

Machpelah* 115, 116, 124
Merion (Lower Merion) 79, 90
Mikveh Israel (Federal Street) 100–101
Mikveh Israel (Market Street) 101, 103
Mikveh Israel (Spruce Street) 17, 79, 91, 98–99
Montefiore (Rockledge) 102
Montrose (Upper Darby) 112
Monument* 49, 115, 118–119
Mother Bethel A.M.E. Church* 79, 81
Mount Carmel 91, 102
Mount Lawn (Sharon Hill) 79
Mount Moriah 6, 49, 50–53, 78, 87, 104, 110
Mount Peace 6, 49, 121
Mount Sinai 91, 102
Mount Vernon 6, 49, 54–55
Mount Zion 85
Mutual Burying Ground* 115, 124

Naval Asylum Burial Grounds* 35, 38
New Cathedral 91, 97
Northwest Square (Logan Circle)* 15
Northwood 62, 107

Odd Fellows* 49, 115, 120–121, 123
Old Oaks* 49, 123
Old Pine Street Presbyterian Church 9, 19
Olive* 79, 85, 88, 115

Palmer (Kensington Burial Ground) 65, 75
Pennypack Baptist Church 65, 77
Philadelphia Memorial Park (Frazer) 124
Philadelphia National 51, 65, 71, 86, 117

Rodeph Shalom* 91, 103
Ronaldson's/Philadelphia* 9, 11, 21, 115, 116
Roosevelt Memorial Park (Trevose) 91, 103

St. Augustine's Catholic Church 91, 93
St. Elizabeth's Convent (Bensalem) 41
St. George's United Methodist Church* 9, 19
St. James Kingsessing Episcopal Church 78
St. Joachim's Catholic Church 94
St. John's Evangelical Lutheran Church* 115
St. Joseph's Burial Ground* 92, 94
St. Joseph's Catholic Church 17, 91, 92
St. Mary's Cemetery* 115

St. Mary's Catholic Church 91, 92
St. Michael's Lutheran Church* 9
St. Michael's Lutheran Church (Germantown) 70
St. Paul's Episcopal Church 9, 20
St. Peter's Episcopal Church 9, 18
Say Burying Ground* 16
Second Presbyterian Church* 48, 54, 79, 115
Stephen Smith Home* 88
Strangers' Burial Ground (Washington Square)* 6, 15, 79, 80, 91

Trinity Church Oxford (Episcopal) 76
Trinity Lutheran Church 78

Union Burial Ground* 115, 124
Union Burying Ground (Chestnut Hill)* 65, 72
(United) American Mechanics* 49, 115, 121
Upper/Axe's Burying Ground 65, 69, 79

Welsh Burying Ground* 115
West Laurel Hill (Lower Merion) 33, 111
Whitemarsh Memorial Park (Ambler) 64
Woodlands 4, 6, 35–48, 49, 91

Zion Lutheran Church* 106, 115

*These cemeteries and graveyards have been removed or obliterated.